You Are Here

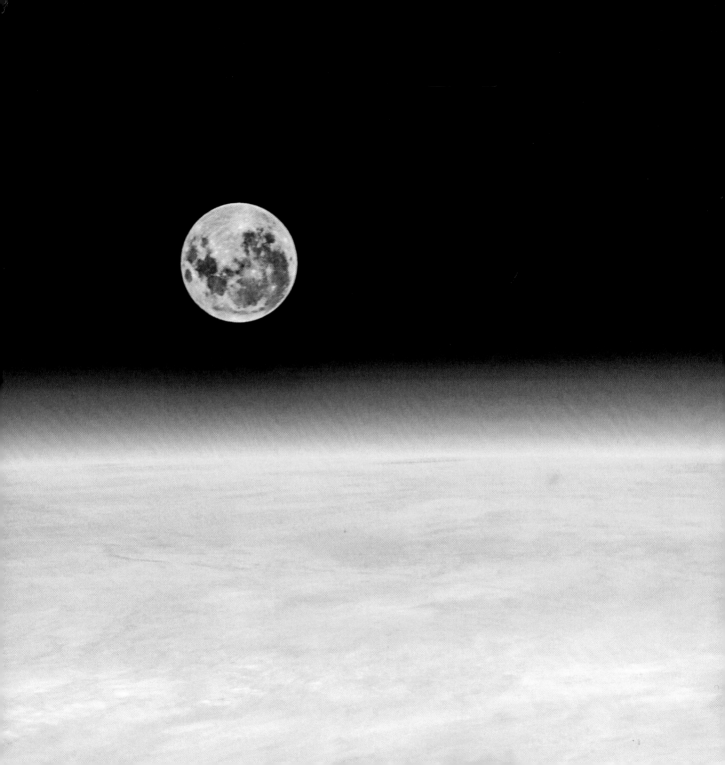

CHRIS HADFIELD

You Are Here

AROUND THE WORLD IN 92 MINUTES

LITTLE, BROWN AND COMPANY

New York Boston London

Little, Brown and Company
Hachette Book Group
1290 Avenue of the Americas, New York, NY 10104
littlebrown.com

First Edition: October 2014
Published simultaneously in Canada by Random House of Canada, Ltd.,
and in Great Britain by Macmillan, October 2014

Little, Brown and Company is a division of Hachette Book Group, Inc.
The Little, Brown name and logo are trademarks of Hachette Book Group, Inc.

The publisher is not responsible for websites (or their content)
that are not owned by the publisher.

The Hachette Speakers Bureau provides a wide range of authors for speaking events.
To find out more, go to hachettespeakersbureau.com or call (866) 376-6591.

Page 200 is a continuation of the copyright page.

A portion of the royalties the author receives from U.S. sales of this edition
will be donated to the Michael J. Fox Foundation for Parkinson's Research.

ISBN 978-0-316-37964-9
LCCN 2014940630

10 9 8 7 6 5 4 3 2 1

RRD-C

Book design by Bryan Erickson

Printed in the United States of America

With love to Eleanor and Roger, my mom and dad,
who bought me my first camera, but more importantly
taught me to be curious about the world.

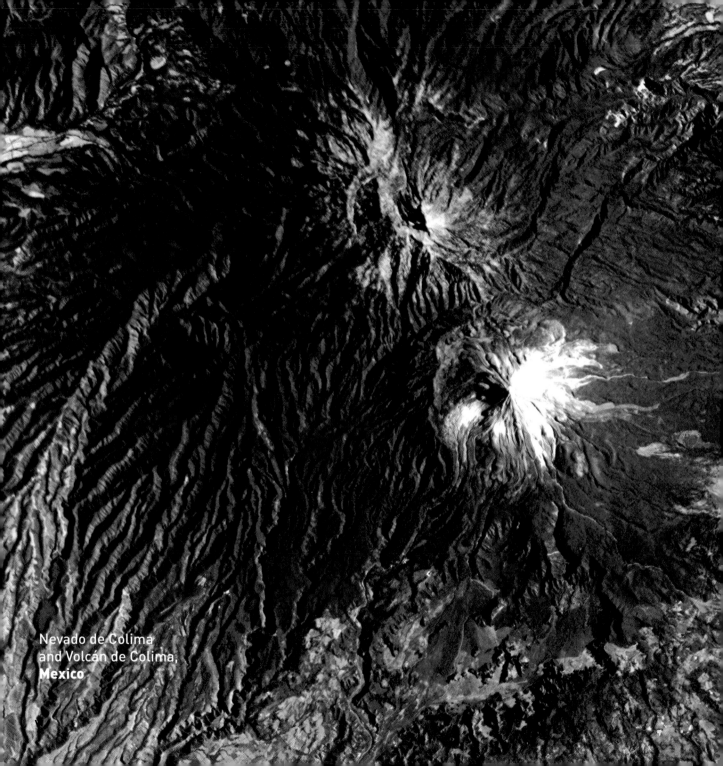

Nevado de Colima
and Volcán de Colima,
Mexico

CONTENTS

Introduction

In 1519 Ferdinand Magellan set sail from Spain to look for a new westward route to Asia. He (and many other sailors) didn't survive the journey. But three years later, what remained of his crew made it home, having completed the first circumnavigation of the globe. Logbooks from the voyage were a revelation, the most complete record yet of our planet's infinite variety.

Nearly 500 years later, the International Space Station completes an orbit of our planet every 92 minutes—16 circumnavigations a day. The ISS is a busy scientific laboratory and NASA budgets zero time for photographing Earth, but there are dozens of cameras on board and astronauts use them daily. The impulse is one Magellan and his crew would recognize: to record—and share—the wonders of the Earth.

Those wonders are endless. My final space mission lasted five months, from December 2012 to May 2013, yet I never tired of looking out the window. I don't think any astronaut ever has, or will. Every chance we have, we float over to see what's changed since we last went around the Earth. There's always something new to see because the

planet itself is rotating, so each orbit takes us over different parts of it. Every crossing of the Pacific, every landfall, brings different weather and vegetation and lighting. And as the seasons change, sunlight, snow and new plant life create new patterns the world over.

During 2,597 orbits of our planet, I took about 45,000 photographs. At first, my approach was scattershot: just take as many pictures as possible. As time went on, though, I began to think of myself as a hunter, silently stalking certain shots. Some eluded me: Brasilia, the capital of Brazil, and Uluru, or Ayers Rock, in Australia. I captured others only after methodical planning: "Today, the skies are supposed to be clear in Jeddah and we'll be passing nearby in the late afternoon, so the angle of the sun will be good. I need to get the long lens and be waiting at the window, looking in the right direction, at 4:02 because I'll have less than a minute to get the shot." Traveling at 17,500 miles per hour, the margin for error is very slim. Miss your opportunity and it may not arise again for another six weeks, depending on the ISS's orbital path and conditions on the ground.

Over time, my ability to understand what I was seeing improved. I started to look forward to certain places and lighting conditions, in the way you love to hear a favorite piece of music. I began to get Nature's sly jokes: rivers that looked like letters of the alphabet, pieces of land that

resembled animals. I became more adept at noticing and interpreting the secrets Earth was discreetly revealing.

My ability to photograph what I was seeing also improved. I started to figure out how to compose a shot in a way that draws attention to particular features and textures. I didn't think of myself as the next Ansel Adams, but I didn't want my pictures to look like satellite images, either. I wanted them to have a human element, to express a point of view.

Like many astronauts, I felt compelled to try to communicate what I was learning, so from orbit, I began posting photos on Twitter and other social media sites. The immediacy of the reactions and interactions, the collective sense of wonder, made me feel as connected to our planet and to other people as I ever have, though I was floating 250 miles above Earth in the company of just five other human beings.

Then I returned from space and started organizing my photos, and promptly came across about a thousand that I wished I'd posted online. I printed out a few to show my family, and was struck by how different they looked on paper—so much sharper and more detailed—than they had on the screen of my laptop. So I tried printing out some of the photos I had posted, and quickly realized I was noticing entirely different things than I had when I was back on the ISS, pressing the shutter. All of which

explains the book you're holding in your hands. These are some of my favorite photos—the majority are new, and all are newly framed with my reflections and explanations.

Like many people, I want to understand our world better. Seeing it from a different angle really helps, and no perspective is more radically different than the one you get when you leave the planet altogether and look back— whether literally, as I did, or through photographs. Those spectacular, two-thousand-mile views make you a lot more aware of the big picture.

Every landscape, whether man-made or wholly natural, has a backstory. Going to space forced me to figure some of them out—and doing that has changed, irrevocably, the way I perceive the world. For instance, I have a much deeper appreciation for the immensity of time. Today, driving down the highway near my house, I pass a hill and register not just a hump of rocky soil, but also the glacier that clawed and bumped it into existence thousands of years ago. I recognize the vast lakes and rivers near my home for what they really are: comparatively puny remnants of an enormous inland body of water, whose traces I saw from the ISS.

Being able to perceive the narrative line behind our planet's shapes, shadows and colors is a bit like having a

sixth sense. It provides a new perspective; we are small, so much smaller even than we may have thought. To me, that's not a frightening idea. It's a helpful corrective to the frantic self-importance we are prone to as a species—and also a reminder to make the most of our moment on this beautiful, strange, durable yet fragile planet.

Through astronaut photography, not just mine but the millions of images archived by NASA and the untold number yet to come, all of us can be explorers, continuing to poke into the world's hidden corners and turn over its mysteries. There are still plenty of those: most of the Earth has been mapped but, to many of us, it remains largely unknown, though it's the only home we will ever have.

You are here—we all are—for life. Let's get to know the place a little better.

Chris Hadfield

Which way is up?

Maps tell us that North is up and South is down. But from the window of a spaceship you see that North and South are not fixed realities—as with lines of latitude and longitude, they're reference points invented by humans to help us navigate the world. Your frame of reference is no longer the same when you're orbiting our rotating planet, and the endless curve of the Earth is stretching and warping familiar shapes to the point where they're not recognizable. Where should the North arrow point: to the Moon? The Sun? Another galaxy altogether? It can be disorienting to see the world from a perspective that's so different from the two-dimensional drawings we're used to. But resist the impulse to turn this book upside down to make it conform to Earthly maps and you'll see our planet in a new way: as it really is, universally speaking.

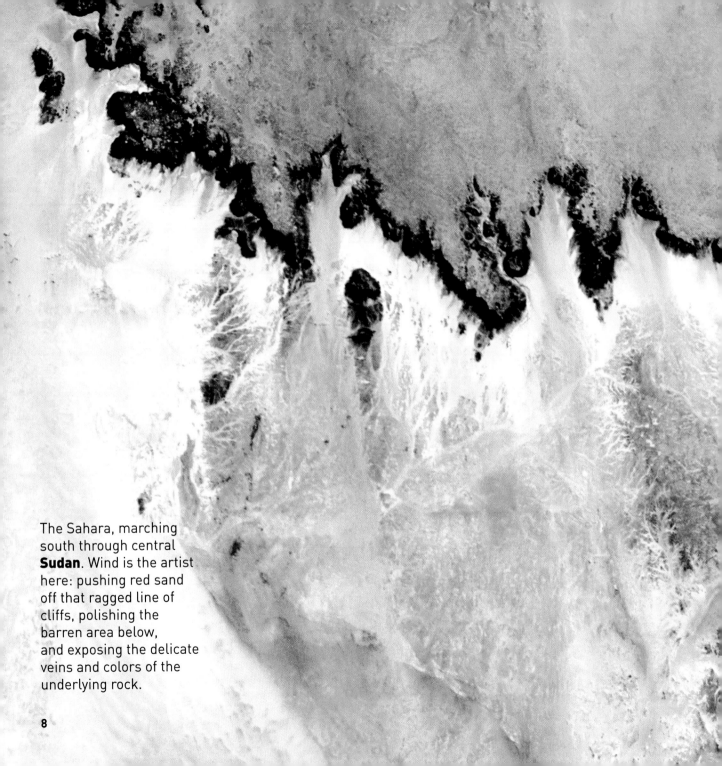

The Sahara, marching
south through central
Sudan. Wind is the artist
here: pushing red sand
off that ragged line of
cliffs, polishing the
barren area below,
and exposing the delicate
veins and colors of the
underlying rock.

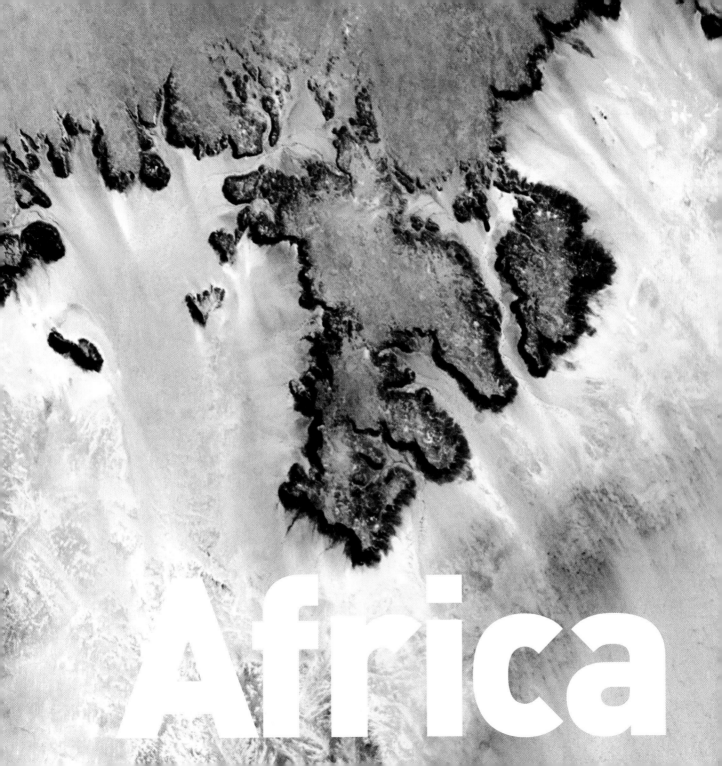

Africa

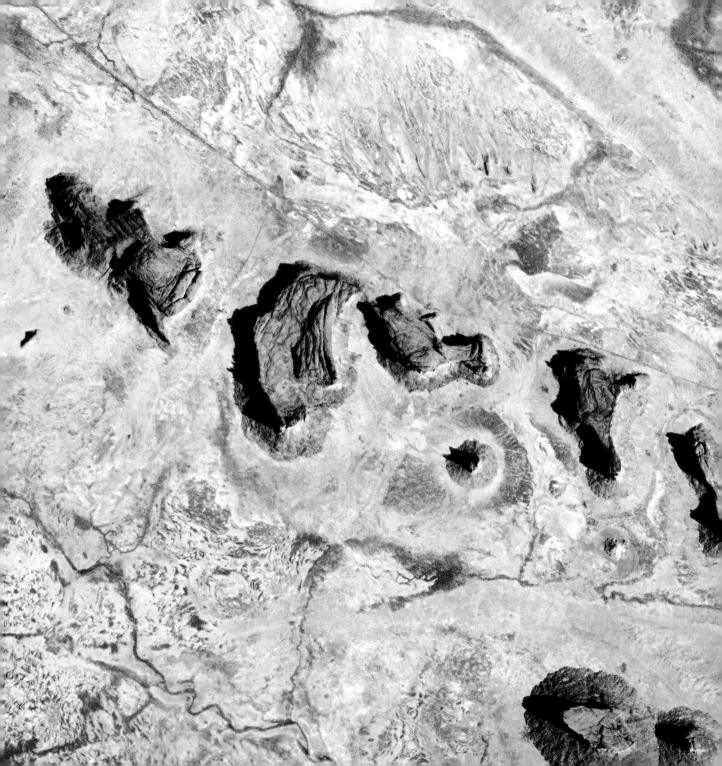

Huge patches of Africa have been sandblasted and scoured clean of vegetation, yet somehow humans have adapted to the harshness of the natural environment, either by discovering how to make a little water go a long way or by pushing on to greener parts of the continent, ones that are fed by rivers and treated more respectfully by the sun.

The small villages of Gai, Tabi, Toupere, Koyo and Boni, in **Mali**

Nature's graffiti has a sense of irony: these sandstone formations on the Ennedi Plateau in northeast **Chad** are surrounded on all sides by desert, with not a farm (or even a road for a chicken to cross) in sight. But once, animals and humans did live here—some of the rocks are covered with vibrant Neolithic paintings.

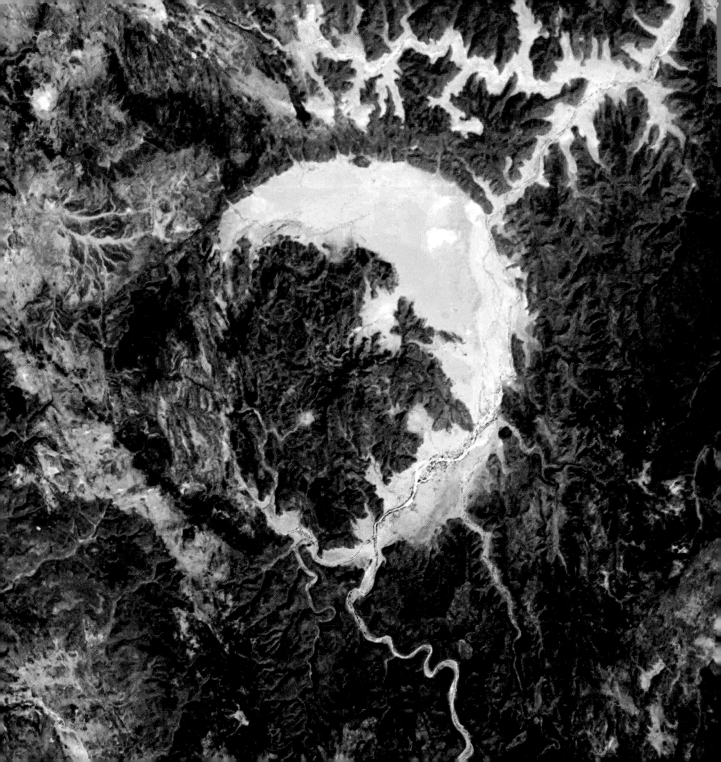

1,000 square miles, about the size of Luxembourg, in southeastern Mauritania

Estimated population: zero

CAPE TOWN, SOUTH AFRICA
9 MILLION + INTERNATIONAL VISITORS/YEAR

YOU ARE
HERE

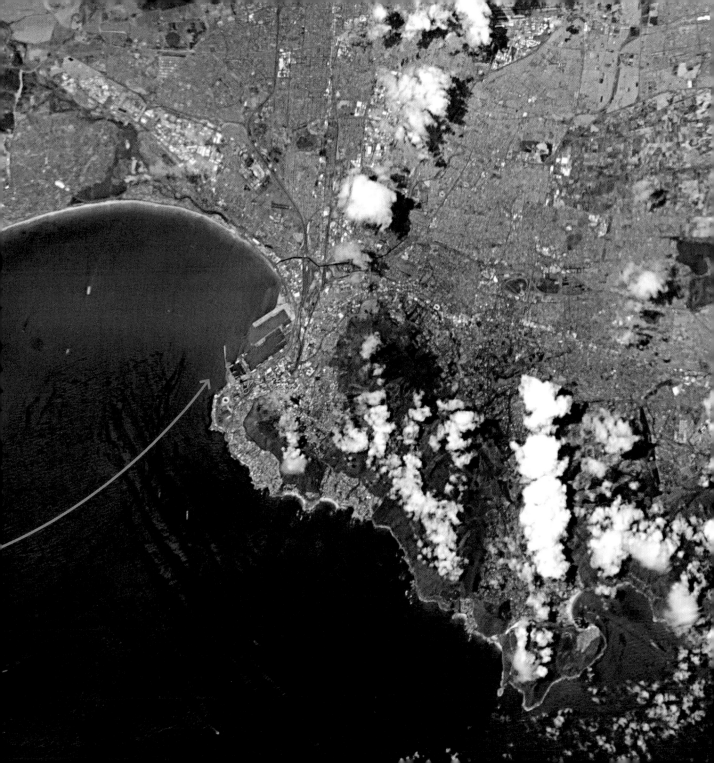

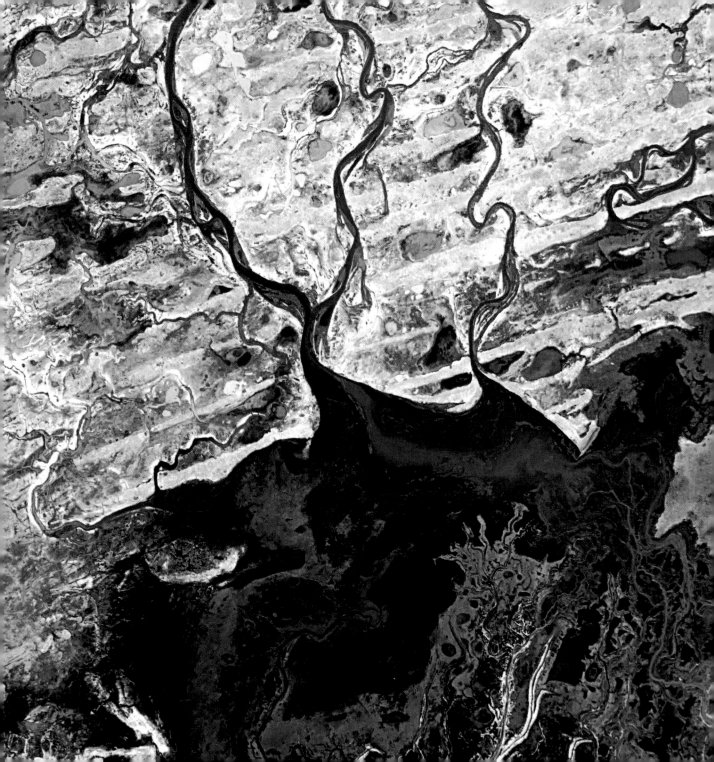

Seasonal flooding turns the inland delta of the Niger River into a lake: Lac Débo, in central **Mali**, a crossroads of geology and life. On the right there's only hardpan: exposed bedrock hostile to vegetation. On the left, an invasion of green, ushered in by the rivers and streams emptying into that giant, swampy splotch of lake. Where there's water, life cannot be denied. I'm pretty sure if we found a way to melt the ice on Mars, life would follow there, too.

Crop circles, coaxed out of the dryness of eastern **Libya** with center-pivot irrigation: a long, elevated sprinkler arm rotates around a pivot, spraying a circle of well water on crops below— you can see exactly where the water stops and plants refuse to grow.

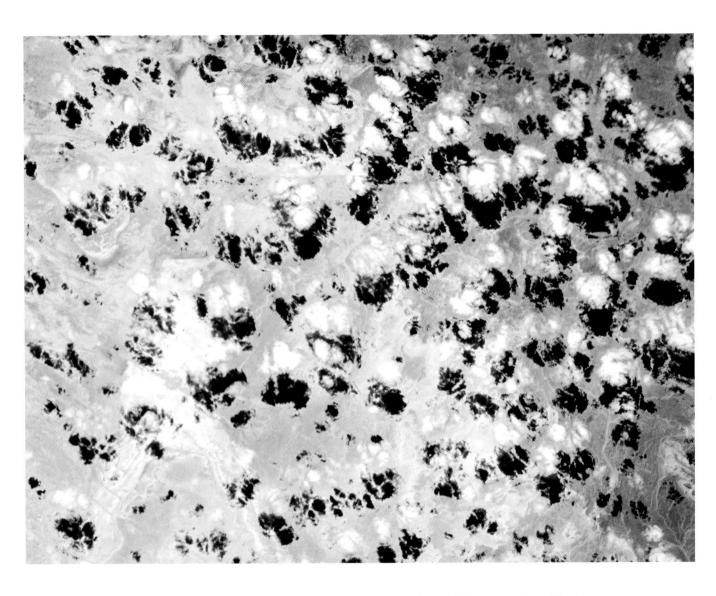

Nature's circles are usually more whimsical and quite a bit less precise, like these popcorn puffs of cloud drifting over the yellow sands of **Egypt**. Squint, and the pattern resolves itself differently: it's the hide of a cheetah, drawn freehand.

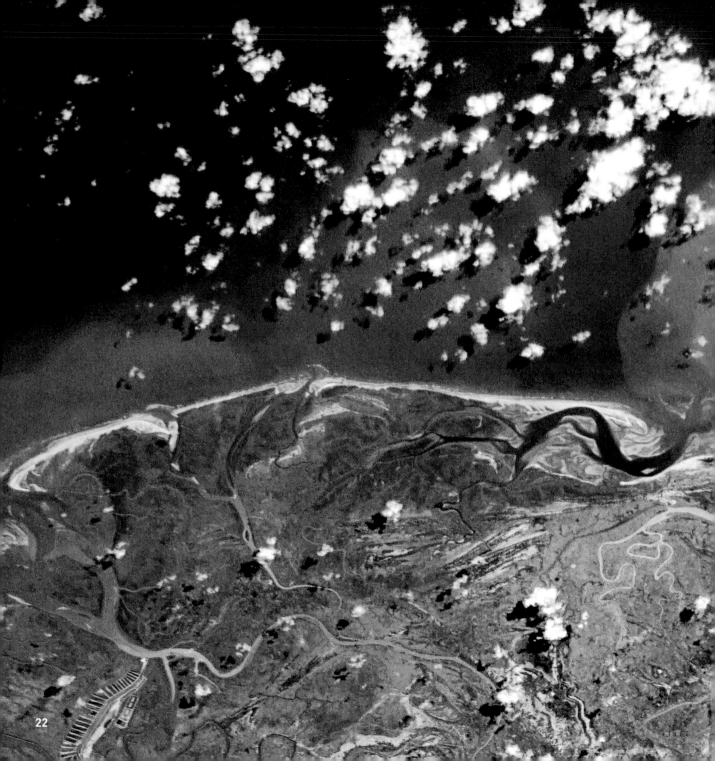

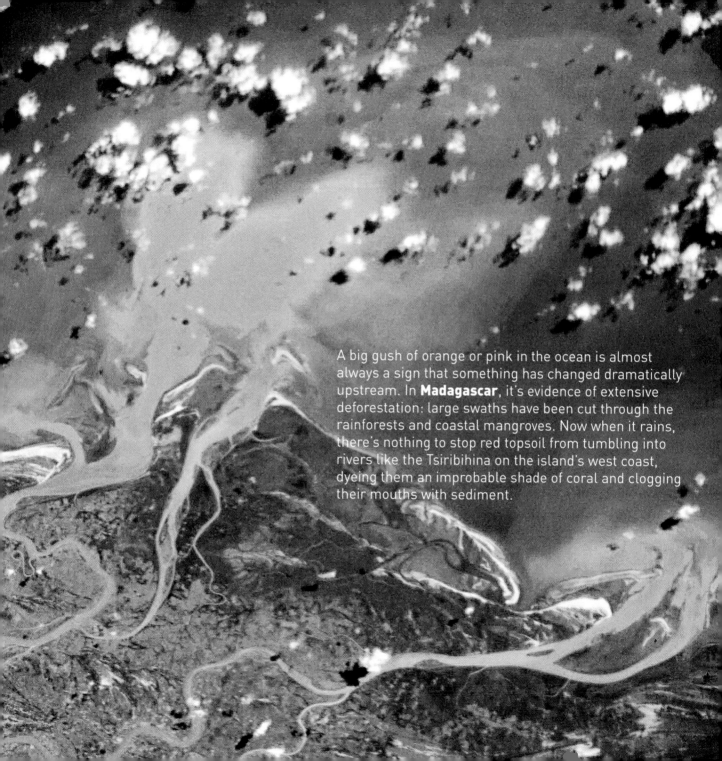

A big gush of orange or pink in the ocean is almost always a sign that something has changed dramatically upstream. In **Madagascar**, it's evidence of extensive deforestation: large swaths have been cut through the rainforests and coastal mangroves. Now when it rains, there's nothing to stop red topsoil from tumbling into rivers like the Tsiribihina on the island's west coast, dyeing them an improbable shade of coral and clogging their mouths with sediment.

An
angry
cloud
in an
unstable
air mass,
helpfully
hurling
heavy rain
on the
maize
farms of
Malawi

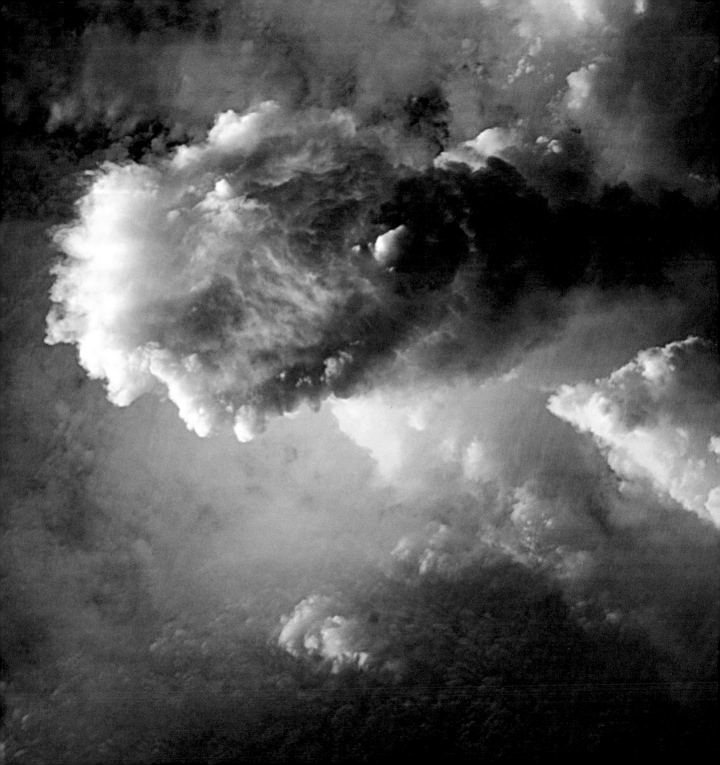

Sand Boxes

Mauritania and Western Sahara, March 21, 2013, at 17,500 mph

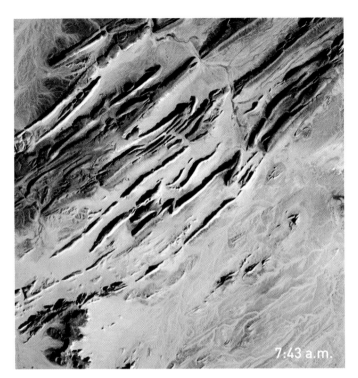

7:43 a.m.

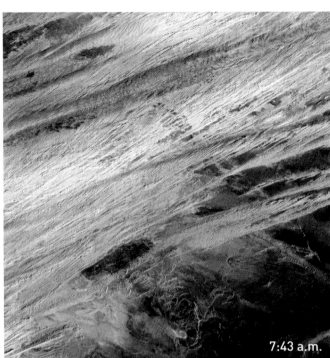

7:43 a.m.

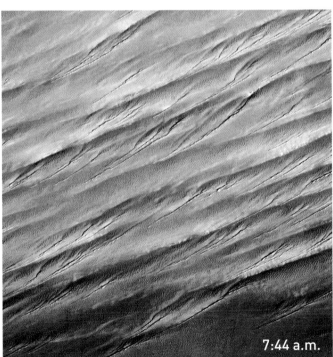

7:44 a.m.

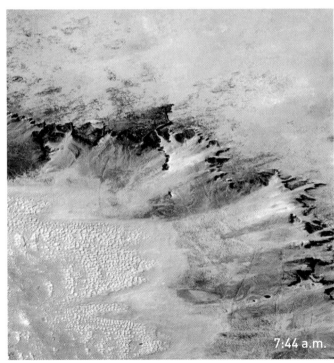

7:44 a.m.

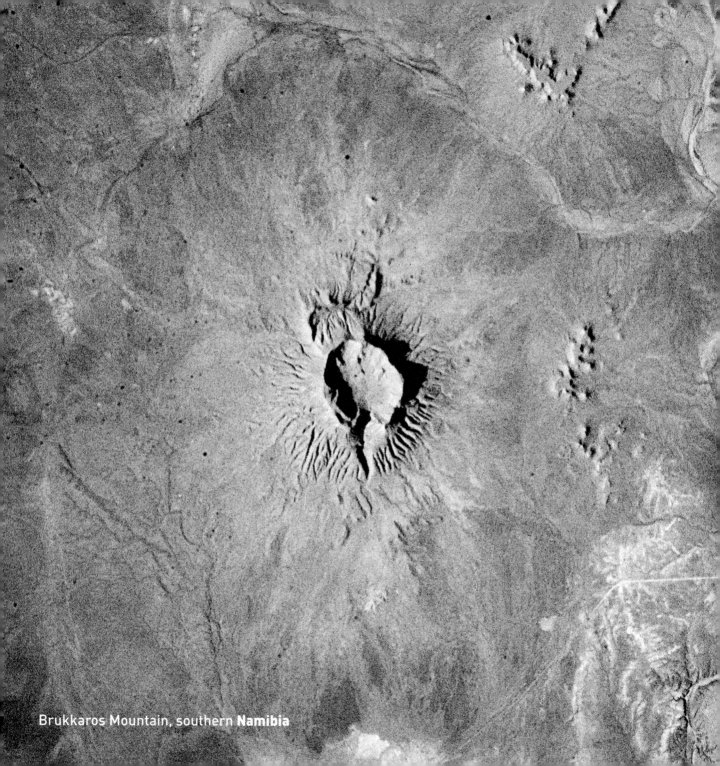

Brukkaros Mountain, southern **Namibia**

A hole in the Earth's skin makes you wonder: volcano, or meteorite impact? Here, lava or weathering has carved deep ravines down the sides, so it's clearly a volcano—extinct, but aging gracefully. In a place that gets very little rain, things last longer. Look at the Moon: a meteorite crashes into it and the crater looks basically unchanged for a billion years, because there's no weathering, no vegetation. With Brukkaros, the story started underground. Rising magma hit groundwater and heated it until it blew out of a vent, blasting rock fragments up into this pile. It's not quite the Moon, so over the past 80 million years there have been some changes; erosion has deepened the depression, leaving a well-preserved ring mountain that might have been ground down to dust in another climate.

The Richat Structure in **Mauritania**, also known as the Eye of the Sahara, is a landmark for astronauts. If you've been busy doing experiments and haven't looked out the window for a while, it's hard to know exactly where you are, especially if you're over a vast 3,600,000-square-mile desert. This bull's-eye orients you, instantly. Oddly, it appears not to be the scar of a meteorite but a deeply eroded dome, with a rainbow-inspired color scheme.

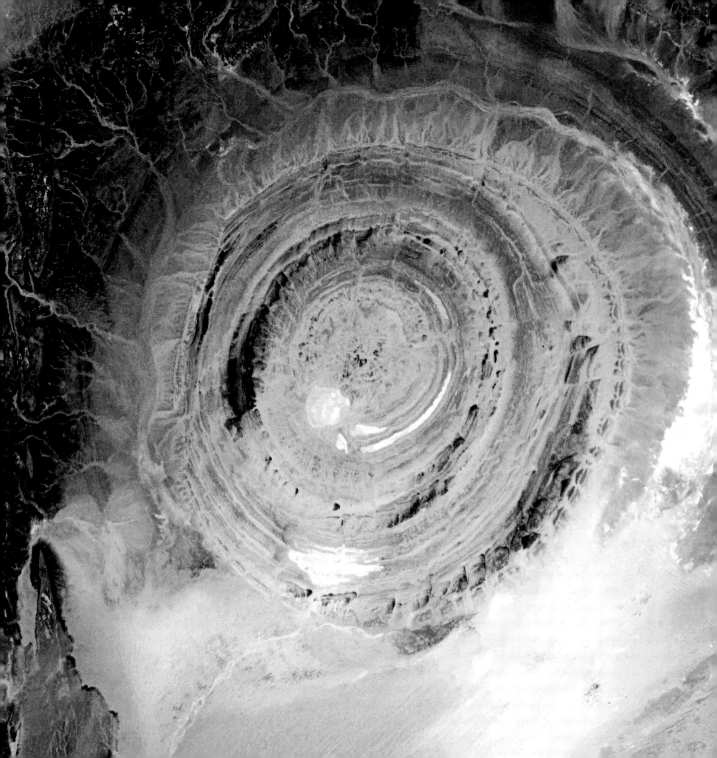

All eyes
and ears

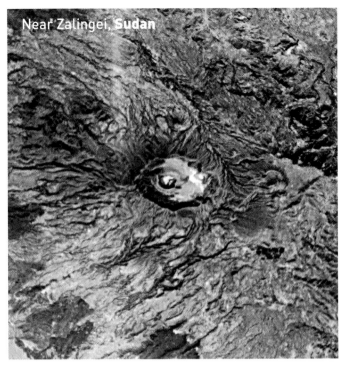

Near Zalingei, **Sudan**

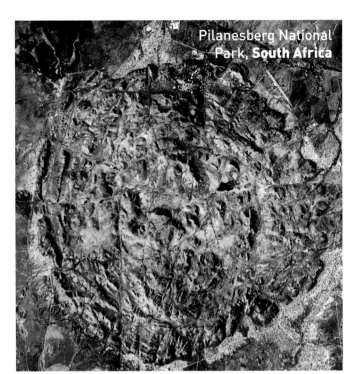

Pilanesberg National Park, **South Africa**

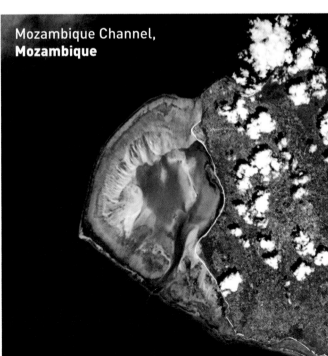

Mozambique Channel, **Mozambique**

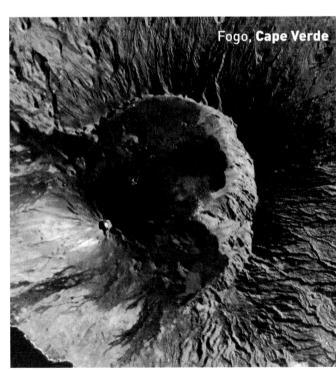

Fogo, **Cape Verde**

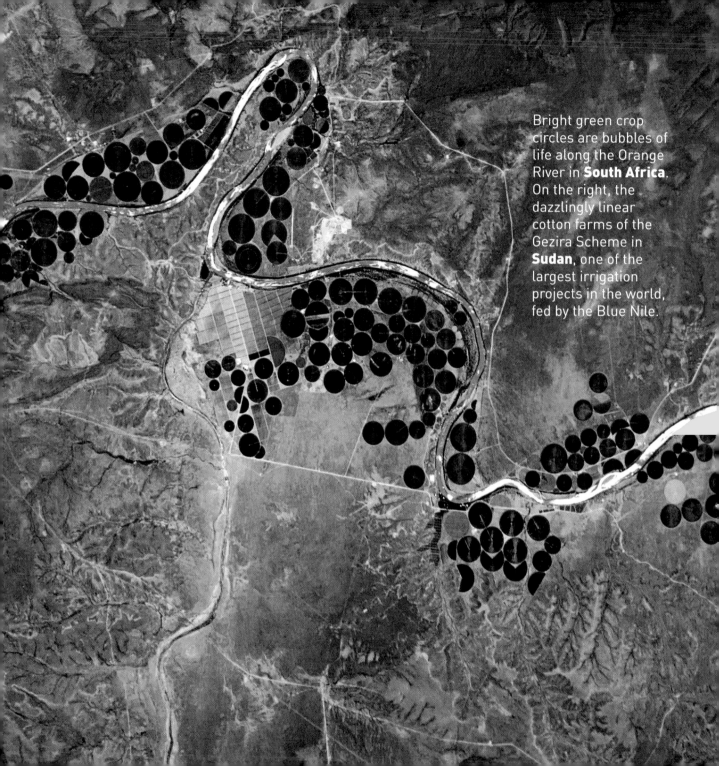

Bright green crop circles are bubbles of life along the Orange River in **South Africa**. On the right, the dazzlingly linear cotton farms of the Gezira Scheme in **Sudan**, one of the largest irrigation projects in the world, fed by the Blue Nile.

The End

The Nile, draining out to the Mediterranean.
The bright lights of **Cairo** announce the opening
of the north-flowing river's delta, with Jerusalem's
answering high beams to the northeast. This 4,258-
mile braid of human life, first navigated end-to-end
in 2004, is visible in a single glance from space.

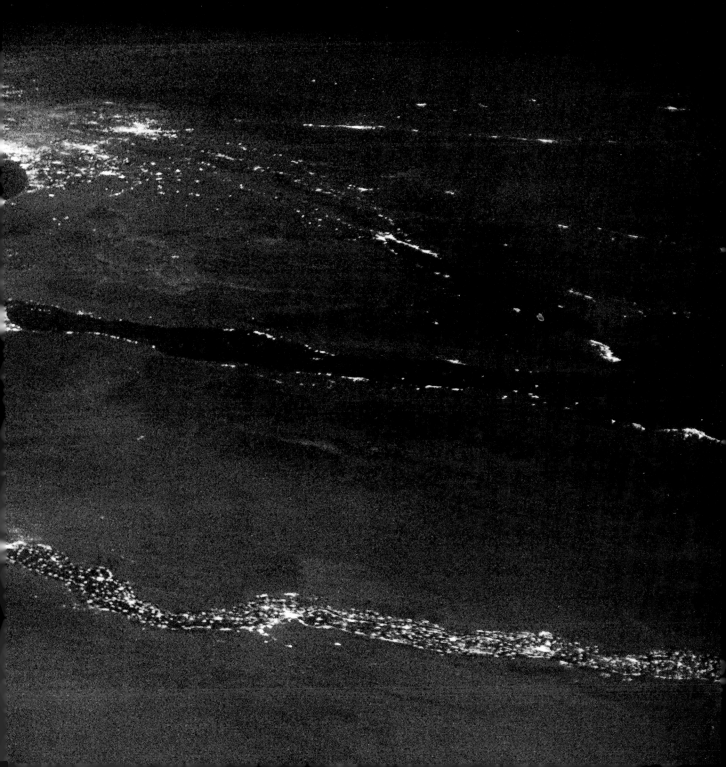

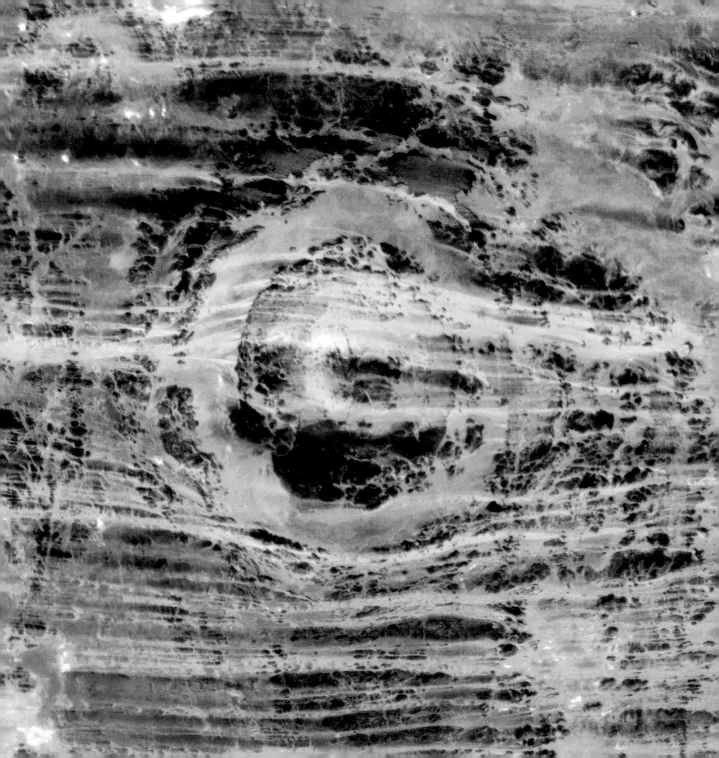

Several hundred million years ago a meteorite slammed into what is now **Chad**, creating the Aorounga crater, which is about 10 miles in diameter. Pockmarked by erosion, Aorounga is decorated with stripes of raised rock that alternate with shallow, wind-cut valleys filled with blowing orange sand. Radar imaging from Space Shuttle missions suggests that circular features stamped into the ground nearby are related; Aorounga might be part of a crater chain formed when a large meteorite blew apart on impact.

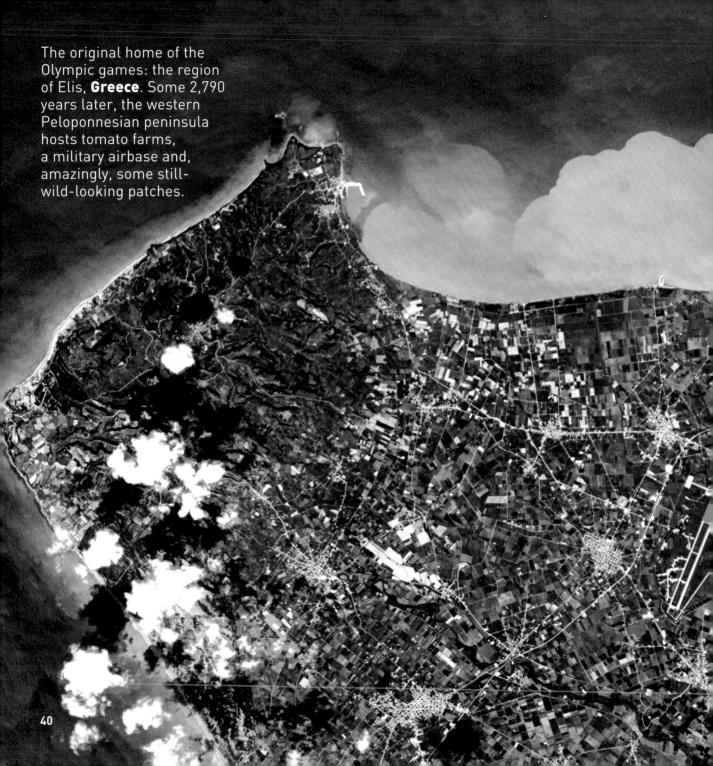

The original home of the Olympic games: the region of Elis, **Greece**. Some 2,790 years later, the western Peloponnesian peninsula hosts tomato farms, a military airbase and, amazingly, some still-wild-looking patches.

Europe

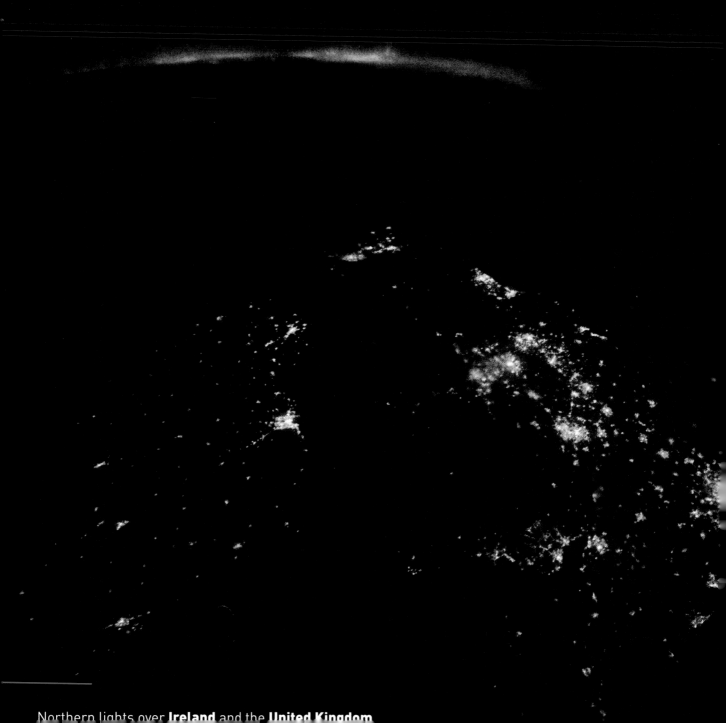

Northern lights over **Ireland** and the **United Kingdom**

Europe's multiple personalities, apparent even 240 miles above Earth, were shaped by the whims of geology and climate—but also because of millennia of cultivation by different groups of humans with evolving ideas about how to make the most of a relatively small continent.

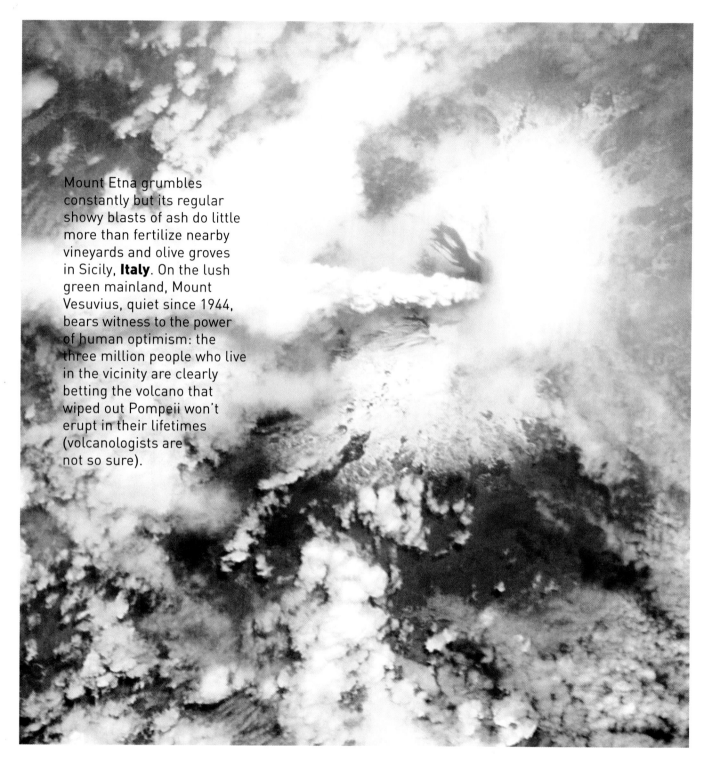

Mount Etna grumbles constantly but its regular showy blasts of ash do little more than fertilize nearby vineyards and olive groves in Sicily, **Italy**. On the lush green mainland, Mount Vesuvius, quiet since 1944, bears witness to the power of human optimism: the three million people who live in the vicinity are clearly betting the volcano that wiped out Pompeii won't erupt in their lifetimes (volcanologists are not so sure).

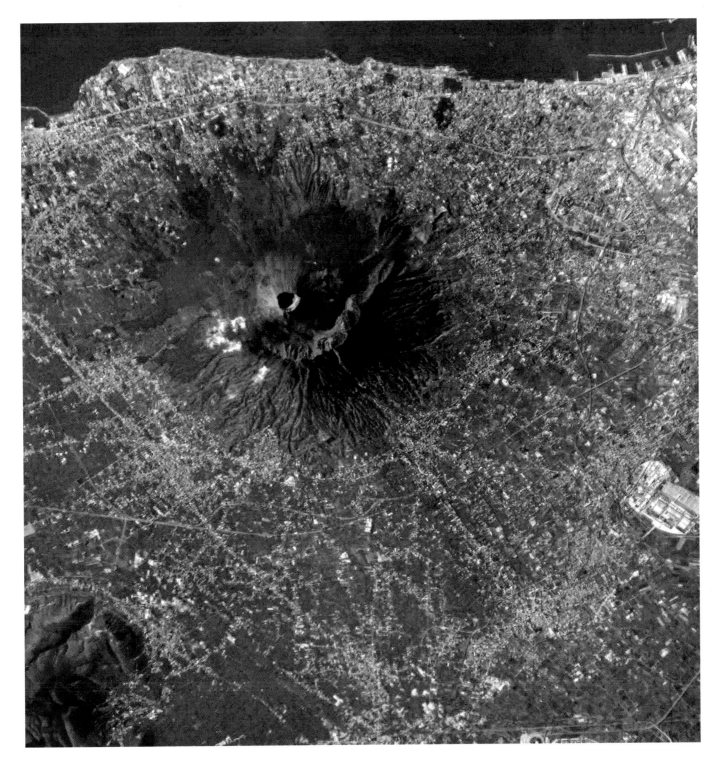

VENICE , FLOATING

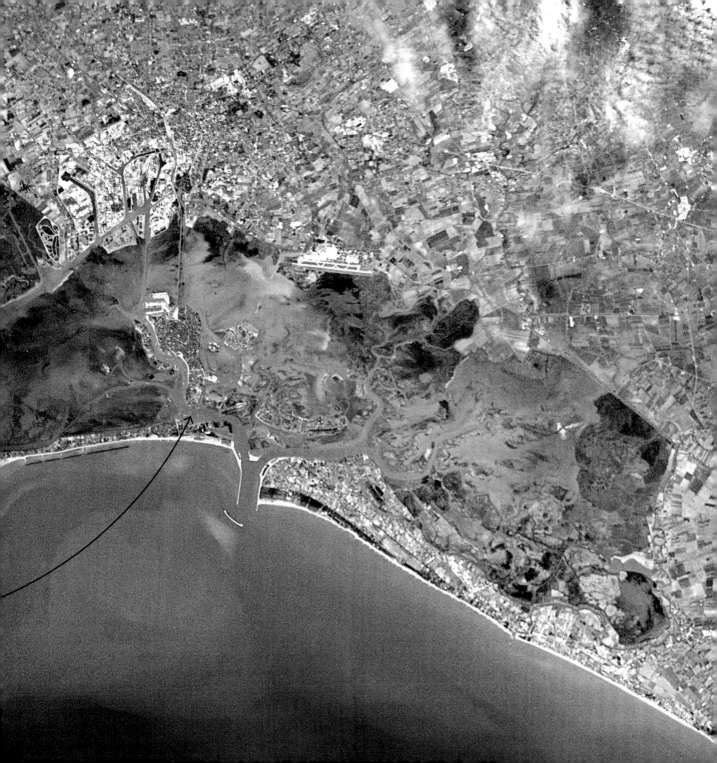

Pareidolia

[parr-i-DOH-lee-ə]

noun The phenomenon of perceiving faces and figures in clouds, landforms and man-made objects such as toast. For instance, looking at the mouth of the Humber River in Hull and seeing a whale gulping krill, or wondering what an elephant is doing in the Bay of Naples, or glancing down at the Crimean coastline and spotting a large bird, pecking at a seed.

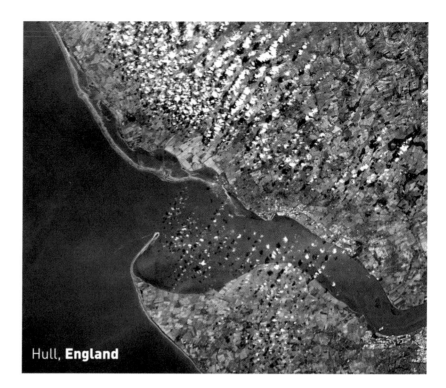

Hull, **England**

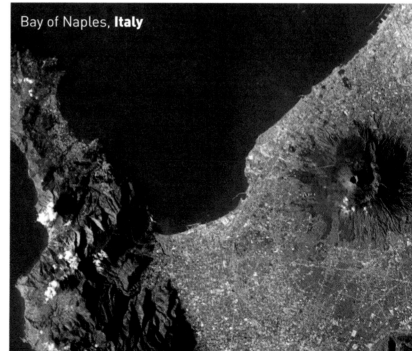

Bay of Naples, **Italy**

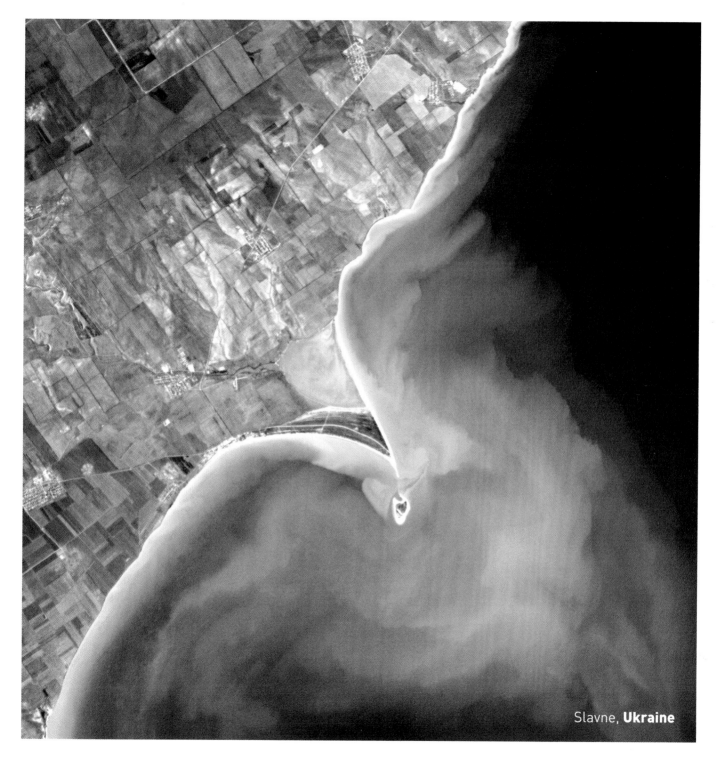

Slavne, **Ukraine**

It's taken hundreds of years for farmers to create the intricate patterns imposed on the flat, highly productive land of Lincolnshire, **England**. One of these fields produced the most important piece of fruit in scientific history: the apple Isaac Newton observed falling from a tree, which prompted his theory of universal gravitation—crucial both for understanding why the Moon doesn't spin away from the Earth and for figuring out the orbital mechanics of space travel. Interesting connection between our high-tech spaceship and this humble, green-and-gray quilt spread out beneath us.

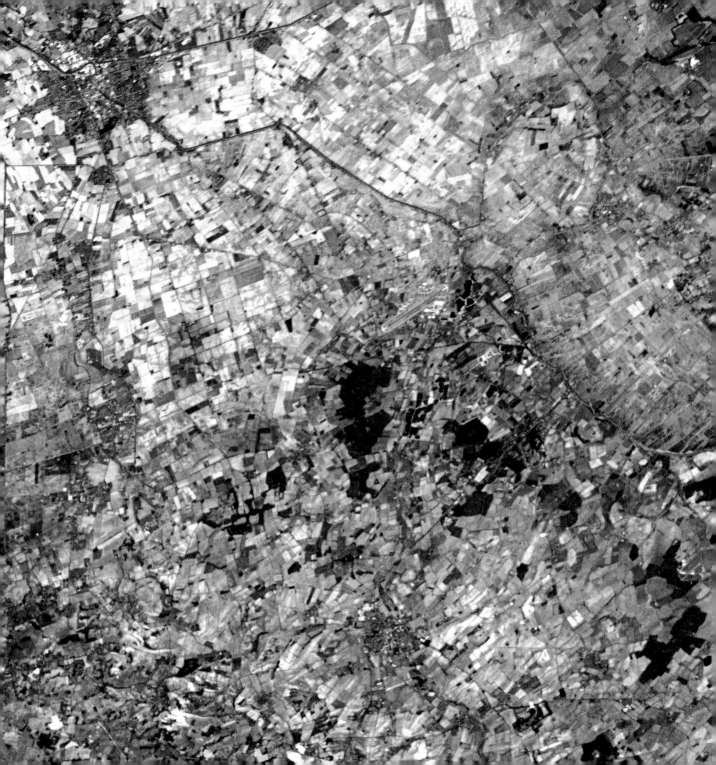

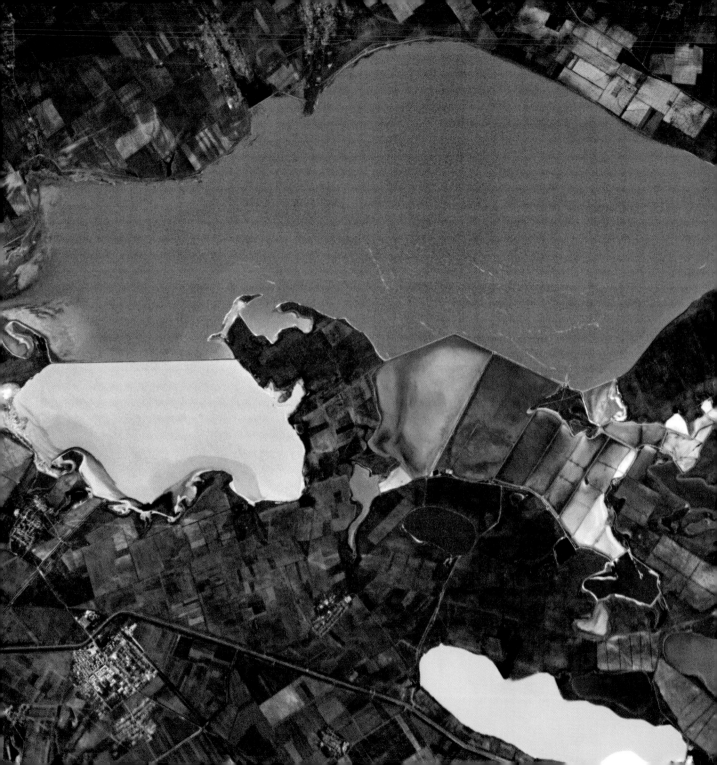

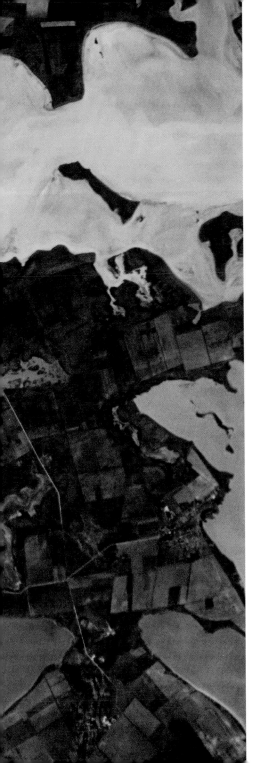

The psychedelic lagoons and marshes of the western Sivash create an unnatural-looking natural border between the Crimean peninsula, bottom, and **Ukraine**'s mainland. Fed by the Sea of Azov, the Sivash is extremely shallow and packed with algae, which makes it ideal for industrial salt extraction (and stinky in warm weather: locals call it the "Rotten Sea"). Green algae thrive in less saline water but halobacteria flourish as salinity increases, introducing pink and red tints. Dams hasten evaporation while ensuring there's no coloring outside the lines.

With a wave of its sand, Plage de l'Espiguette near Montpellier, **France** graphically advertises its attractions.

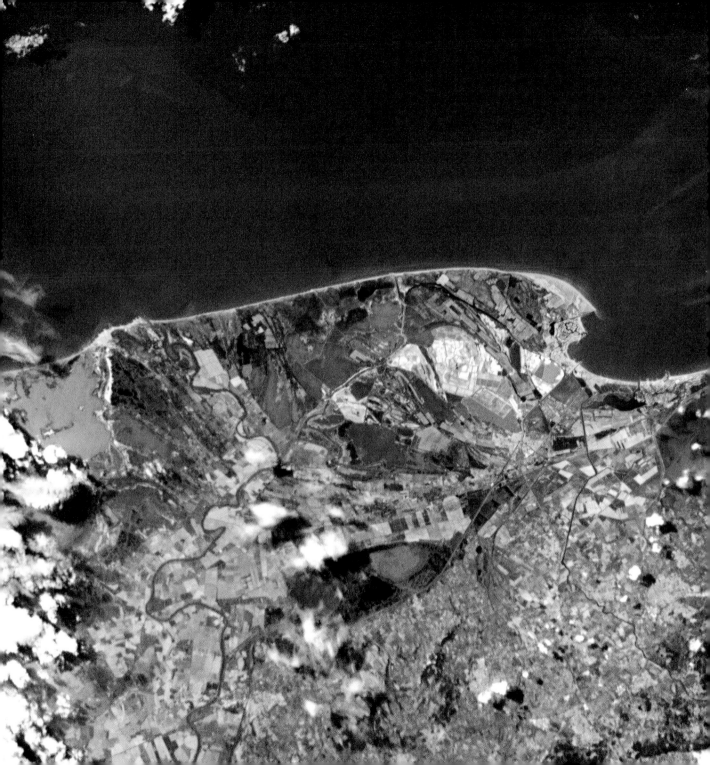

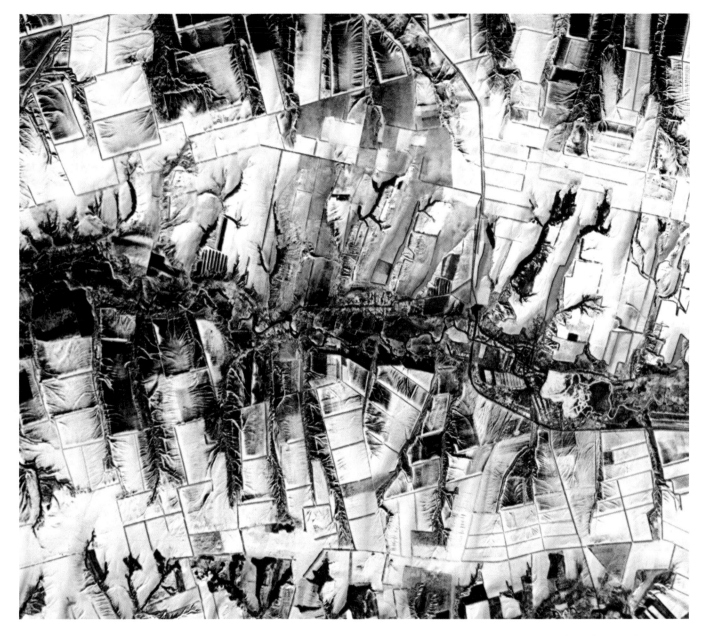

Snow highlights the precision of the bold lines humans have drawn to carve collective and individually owned farms out of the rolling, pillowy hills of Kashary, western **Russia** (main crops: winter wheat and sunflowers—yes, sunflowers).

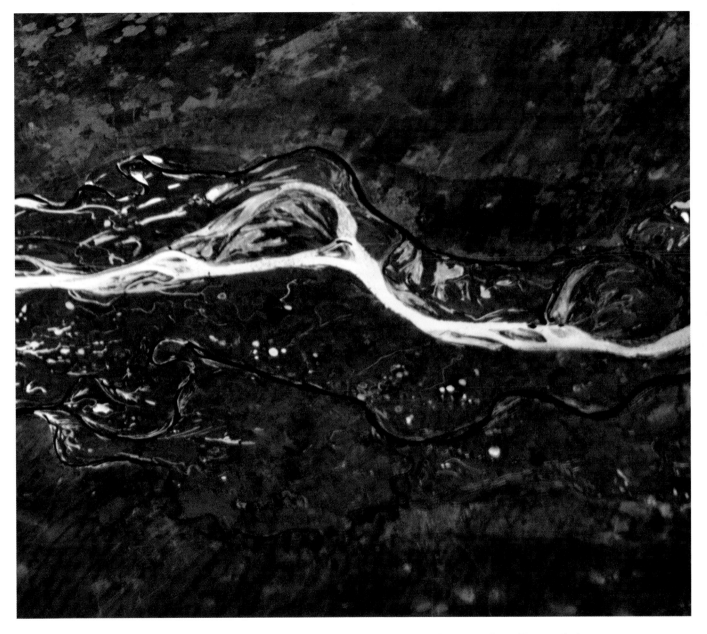

As it empties into the Caspian Sea, **Russia**'s Volga River fans out into Europe's largest inland delta, a mucky, salt-striped haven for caviar-producing sturgeon (which helps explain the grinning chocolate crocodile).

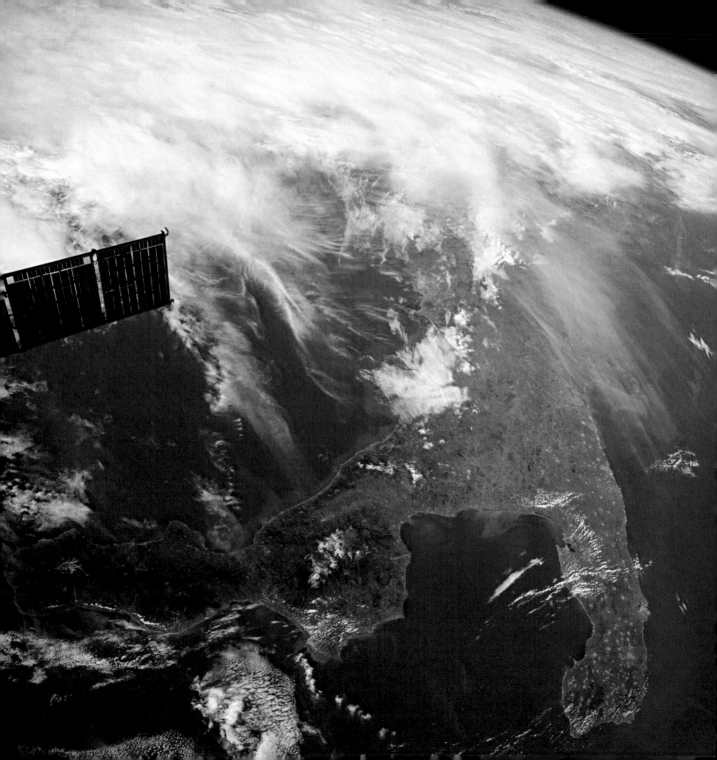

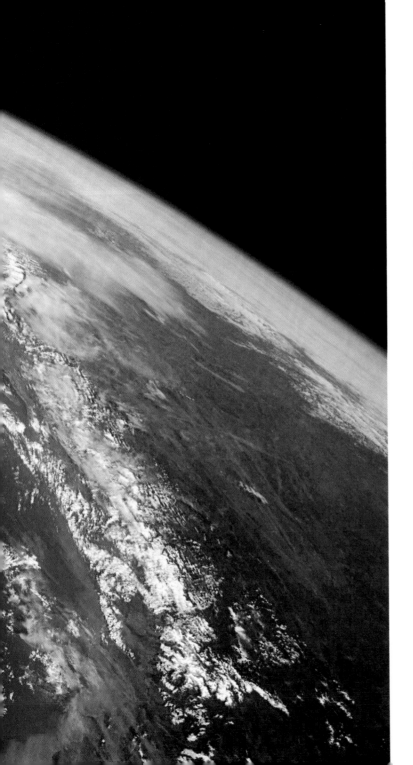

Photobomb

The tip of one of the solar arrays that generate power for the ISS crept into my picture of Italy (always surprises me how much higher the boot's arch looks from this perspective than it does on a map).

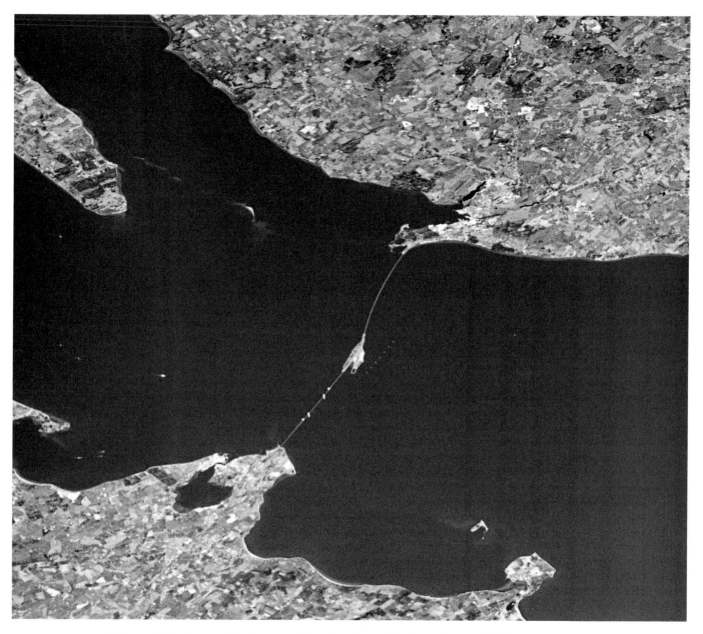

Like a delicate necklace spanning the Great Belt strait, two bridges form an
11-mile fixed link between Zealand and Funen, **Denmark**'s main islands. The ornament in
the middle is tiny Sprogø, tarnished by past use: until 1961, the islet was an escape-proof "home"
for women deemed morally or genetically unfit for motherhood.

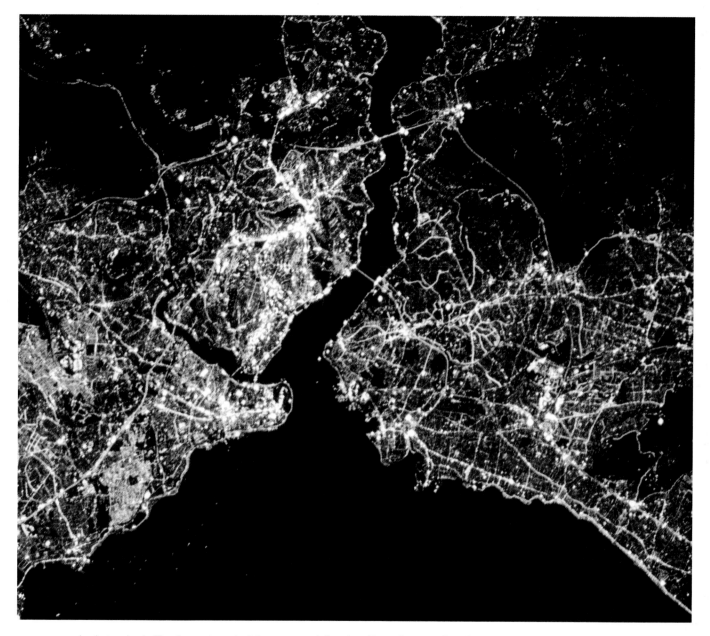

In Istanbul, **Turkey**, two bridges straddle the Bosphorus Strait, one of the boundaries between Asia and Europe. From space it's easy to understand the strait's strategic significance throughout history: it's a sort of liquid bridge, funneling water between the Black Sea and the Mediterranean, via the Sea of Marmara and the Dardanelles.

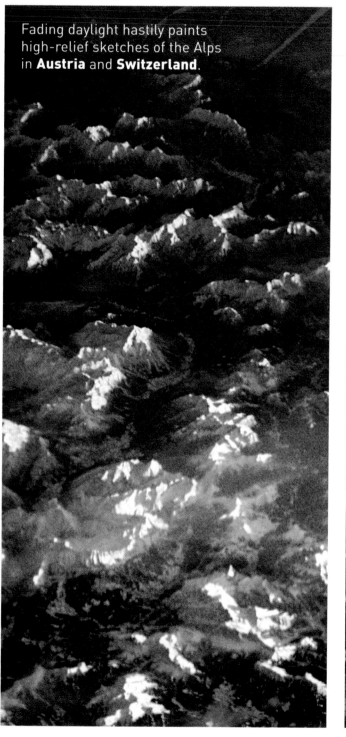

Fading daylight hastily paints
high-relief sketches of the Alps
in **Austria** and **Switzerland**.

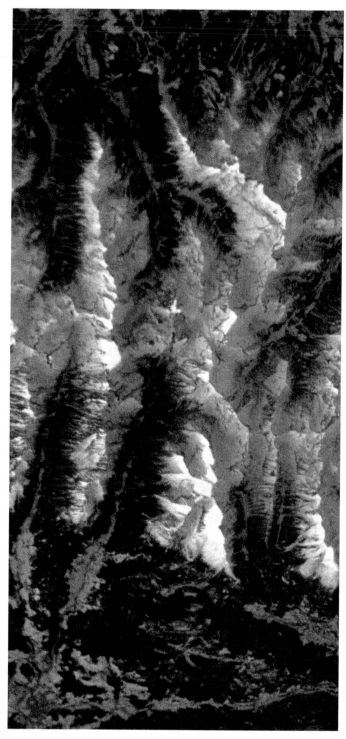

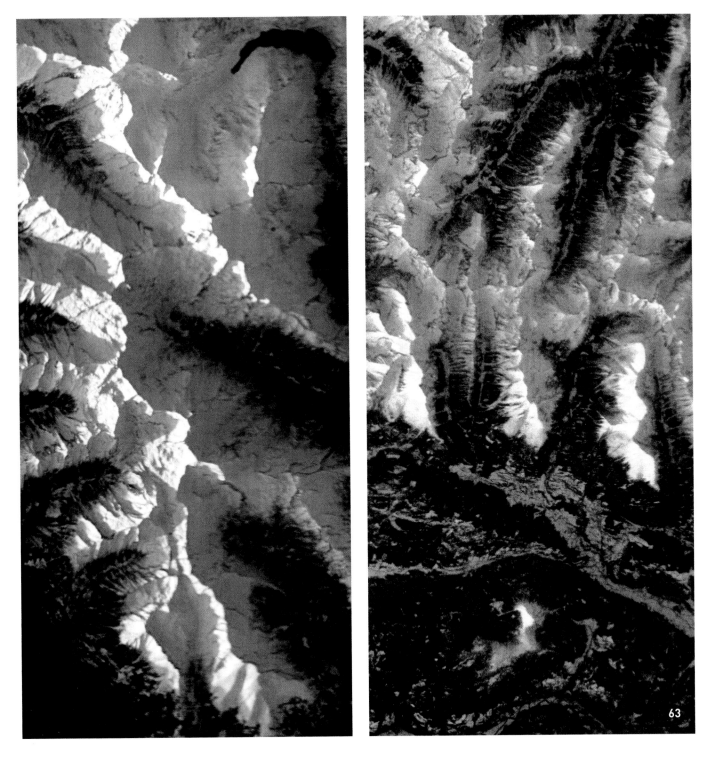

63

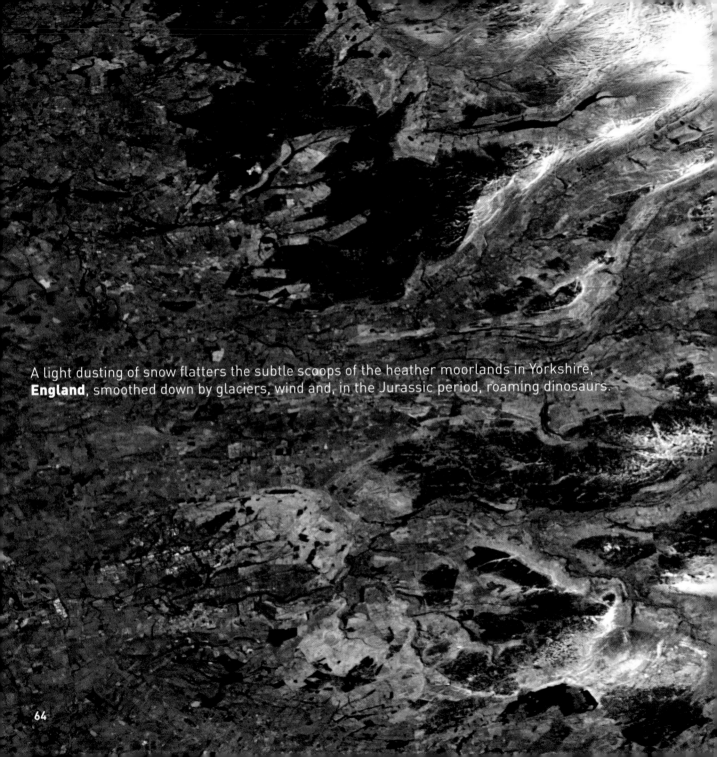

A light dusting of snow flatters the subtle scoops of the heather moorlands in Yorkshire, **England**, smoothed down by glaciers, wind and, in the Jurassic period, roaming dinosaurs.

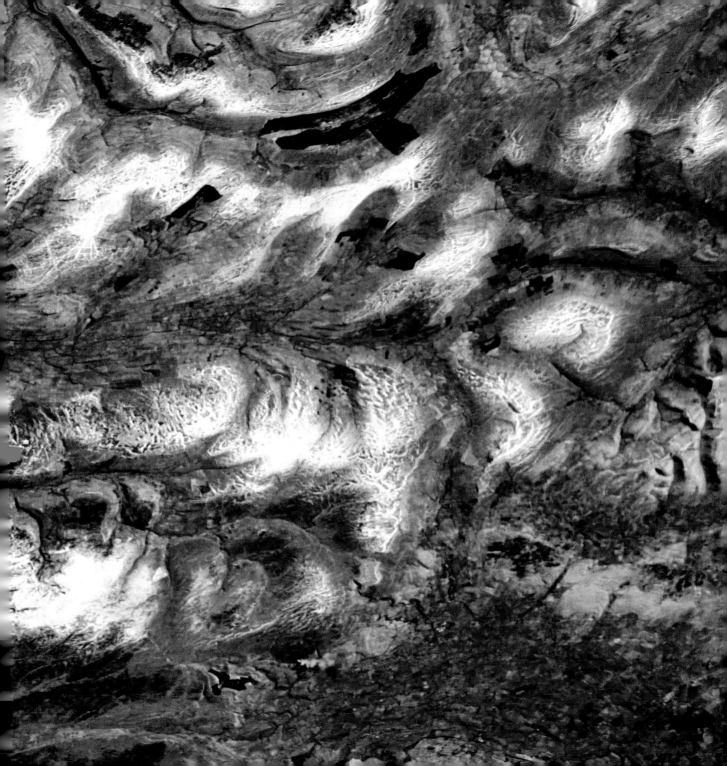

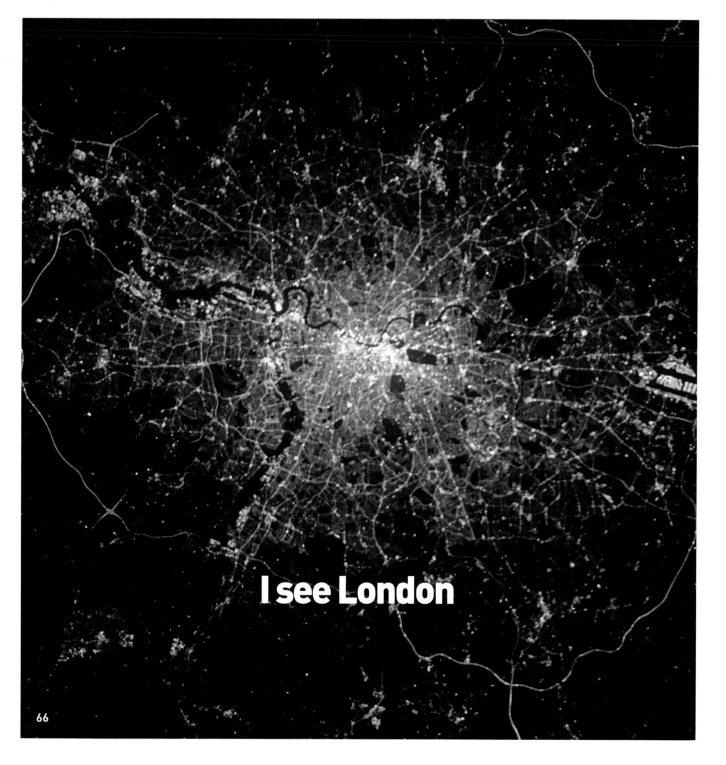

I see London

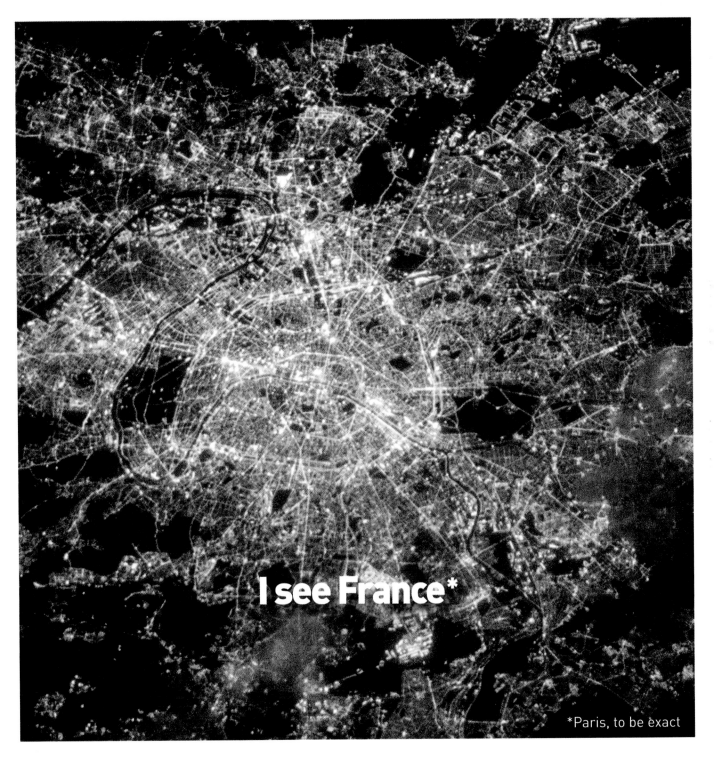

I see France*

*Paris, to be exact

Europe or Asia? Depends where you are in the transcontinental city of Orenburg, **Russia**: everything above the wiggling Ural River is considered Europe, while everything below is Asia.

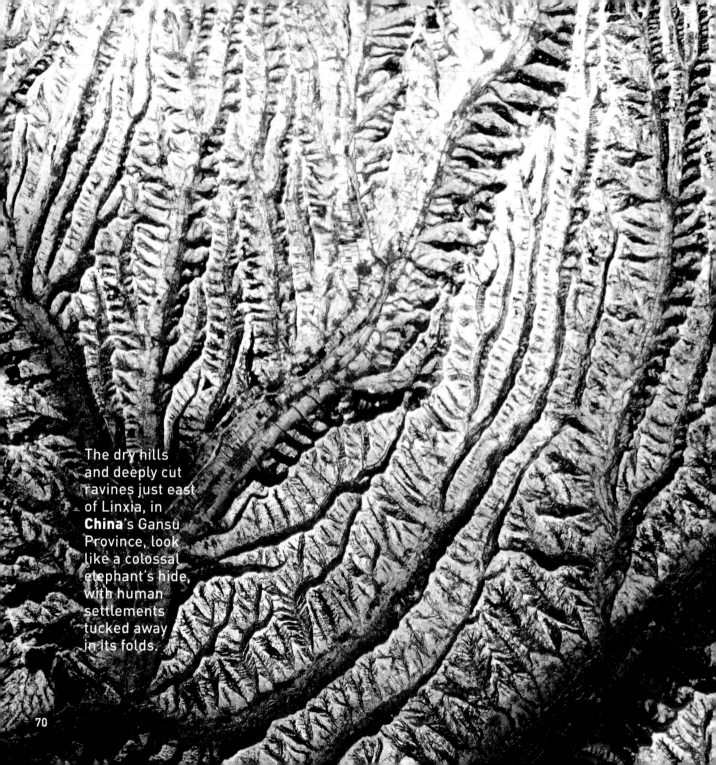

The dry hills and deeply cut ravines just east of Linxia, in **China**'s Gansu Province, look like a colossal elephant's hide, with human settlements tucked away in its folds.

Asia

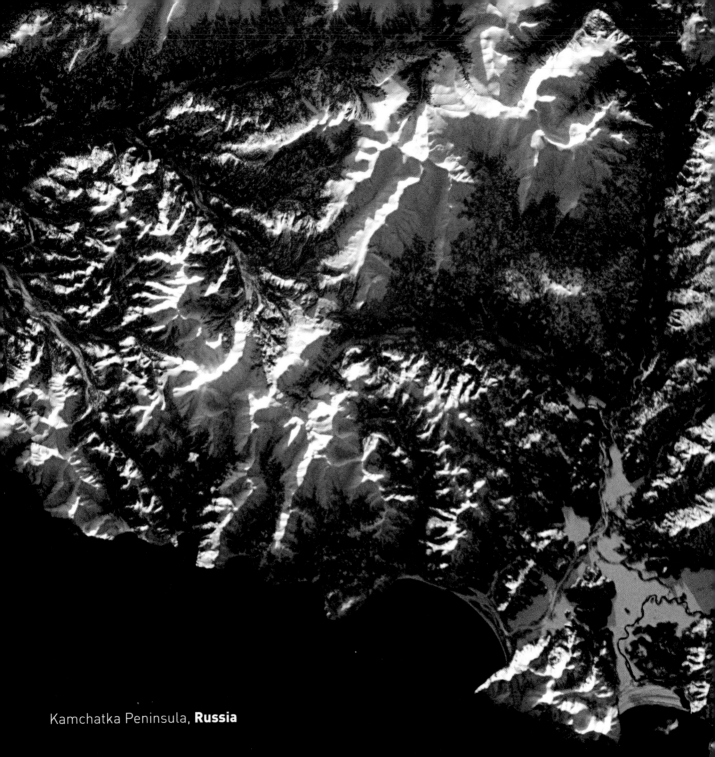

Kamchatka Peninsula, **Russia**

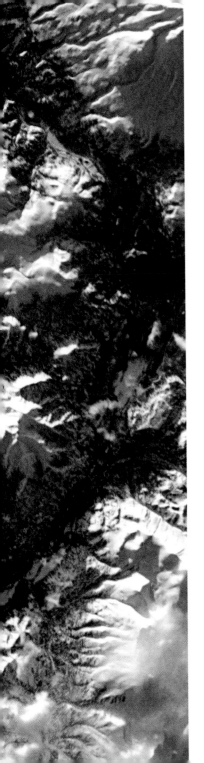

Looking down at our largest and most densely populated continent, I was struck by the endless variety of sharp contrasts, and by the fact that some of the most ravaged and forbidding landscapes on Earth are so incredibly beautiful from space.

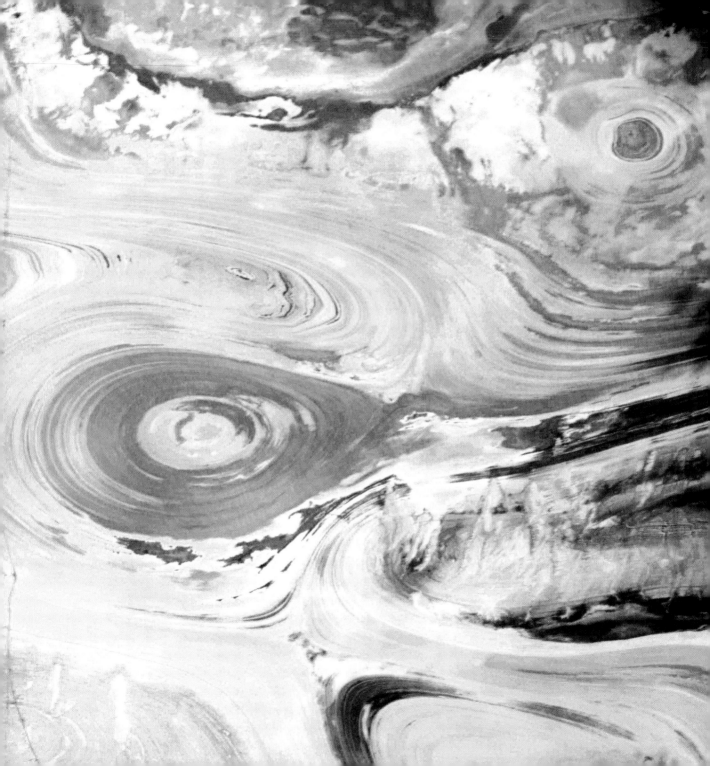

Iran's largest desert, Dasht-e Kavir, is covered with a thick crust of salt, probably left behind by an ocean that dried up many millions of years ago. More recently, eroded salt domes and mud flats twisted like taffy when tectonic plates shifted, leaving behind an eerie and almost uninhabited landscape of oozing, quicksand-like marshes.

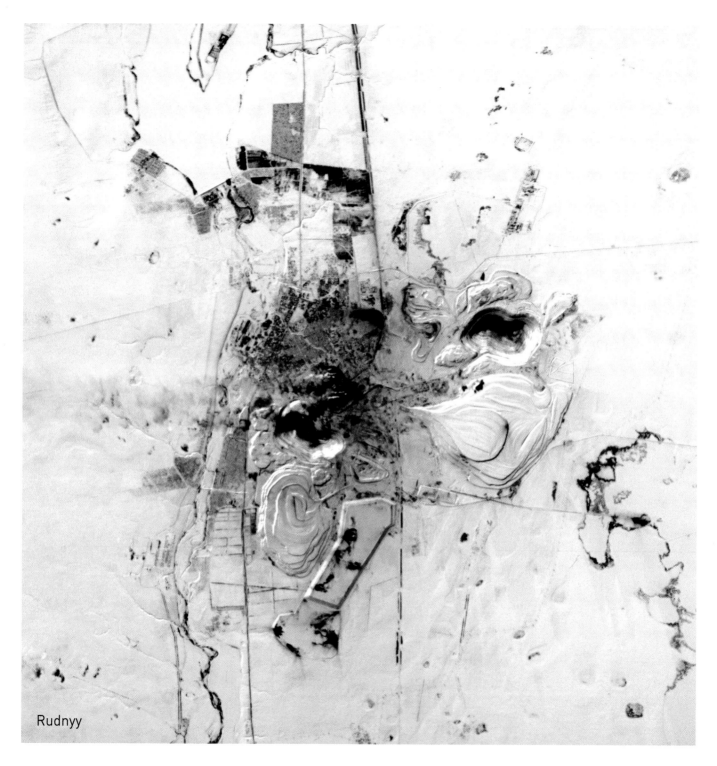

Rudnyy

Black and white prints

Kachar

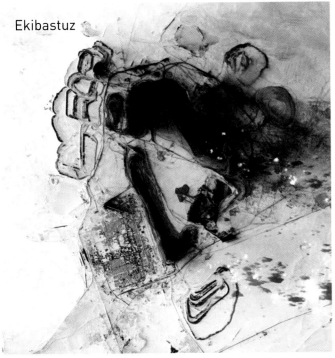

Ekibastuz

Humans digging for coal and minerals create an evidence trail in **Kazakhstan** that snow cannot conceal: not just holes in the ground and black blurs of particulate on the snow, but foothills of slag and ore so large that from space they look like topographic maps, with their own carefully drawn contour lines.

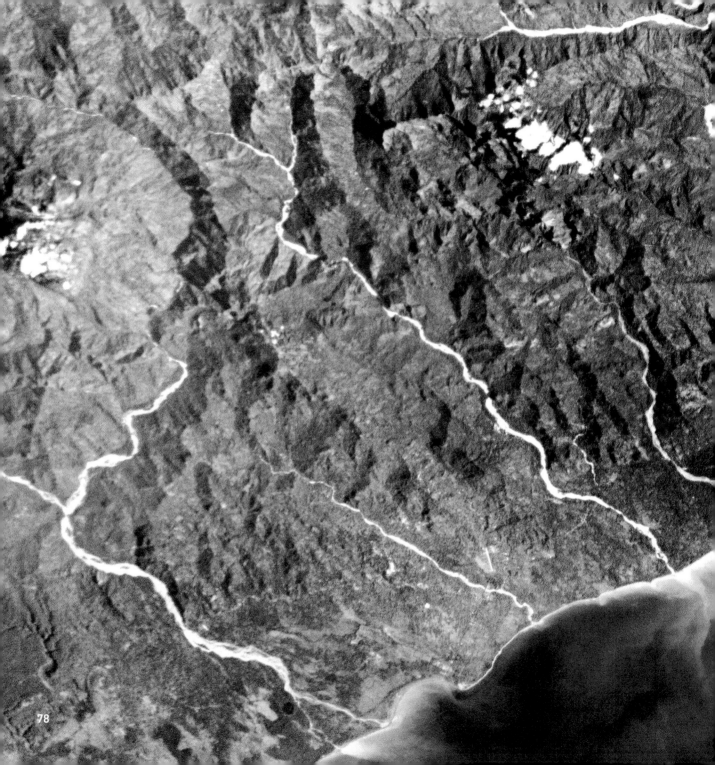

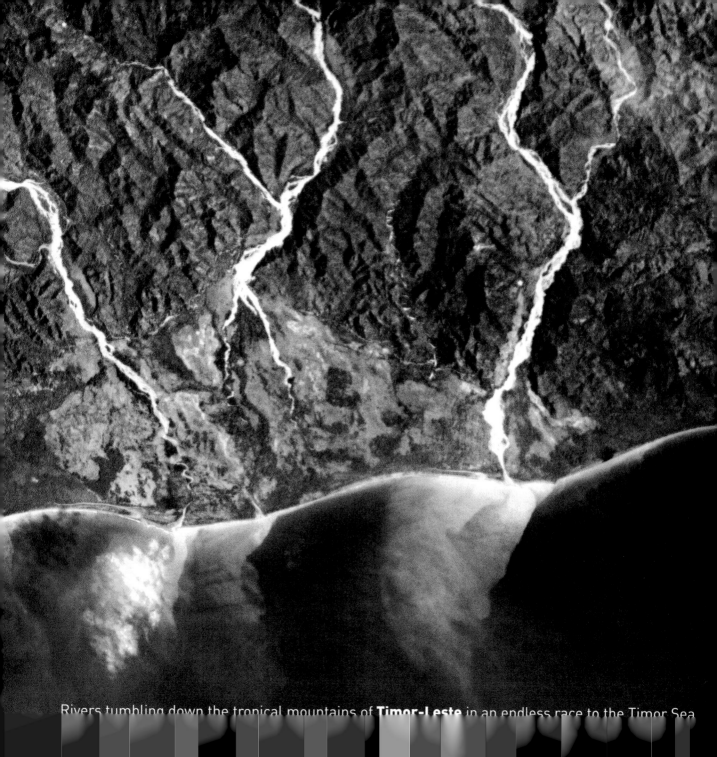

Rivers tumbling down the tropical mountains of **Timor-Leste** in an endless race to the Timor Sea.

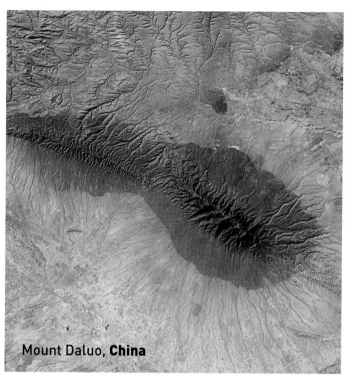

Mount Daluo, **China**

Slugs and

snails and

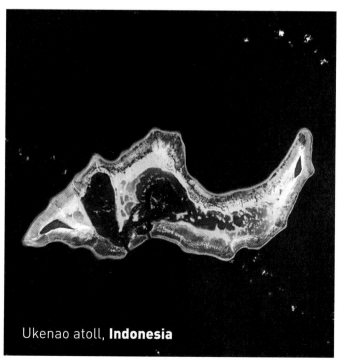

Ukenao atoll, **Indonesia**

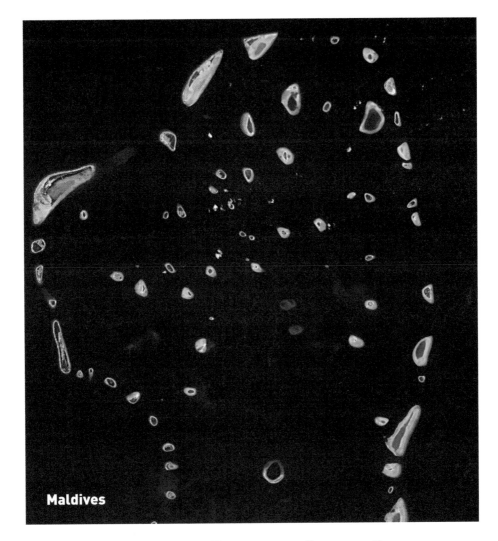

Maldives

puppy dog ... heads

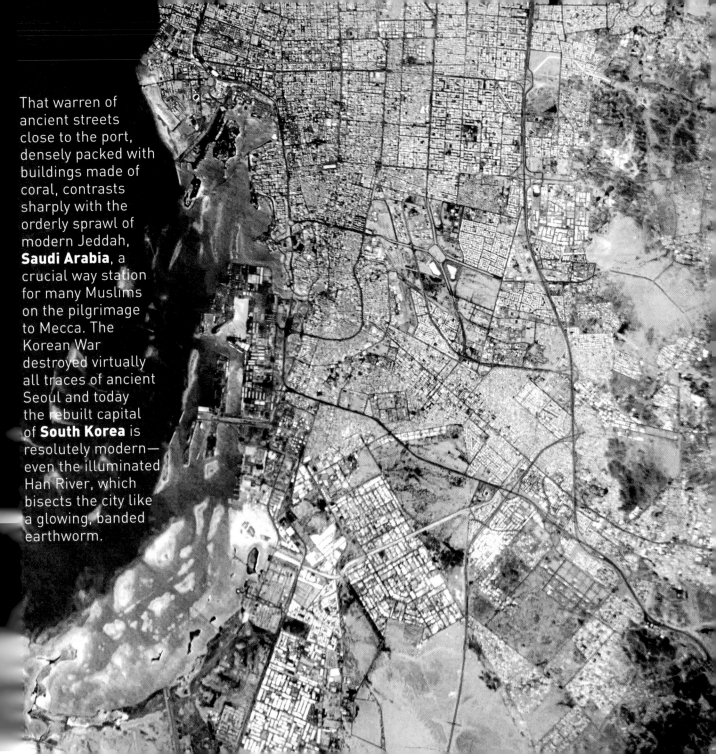

That warren of ancient streets close to the port, densely packed with buildings made of coral, contrasts sharply with the orderly sprawl of modern Jeddah, **Saudi Arabia**, a crucial way station for many Muslims on the pilgrimage to Mecca. The Korean War destroyed virtually all traces of ancient Seoul and today the rebuilt capital of **South Korea** is resolutely modern—even the illuminated Han River, which bisects the city like a glowing, banded earthworm.

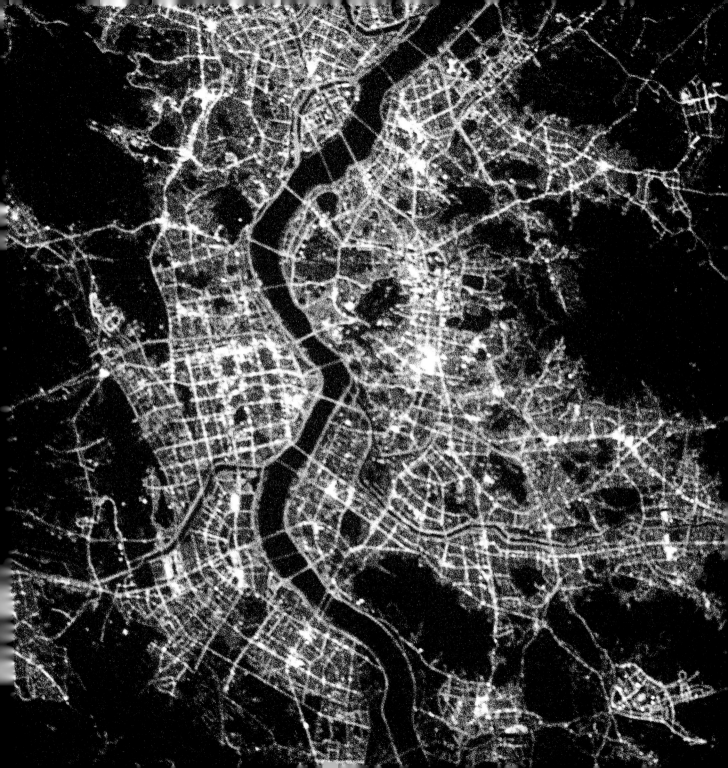

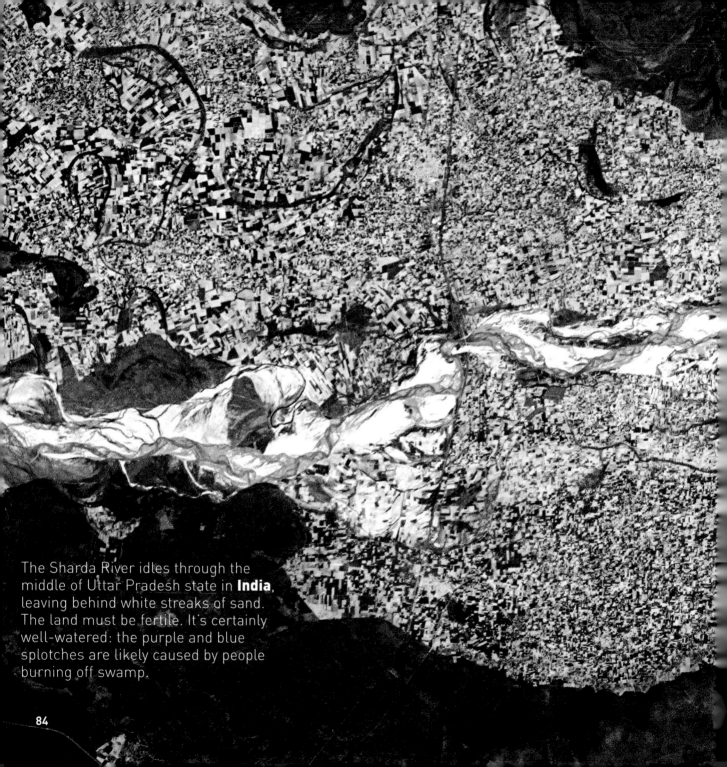

The Sharda River idles through the middle of Uttar Pradesh state in **India**, leaving behind white streaks of sand. The land must be fertile. It's certainly well-watered: the purple and blue splotches are likely caused by people burning off swamp.

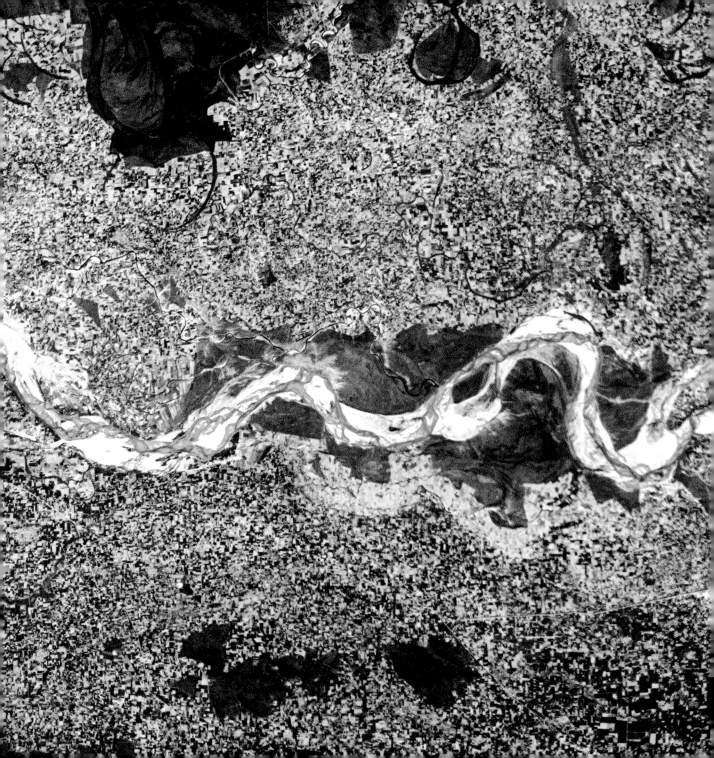

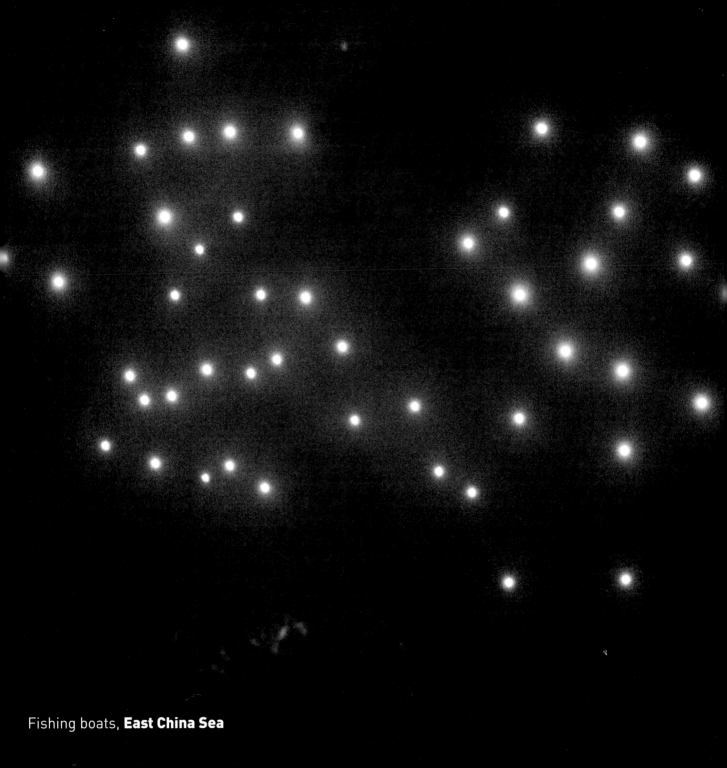

Fishing boats, **East China Sea**

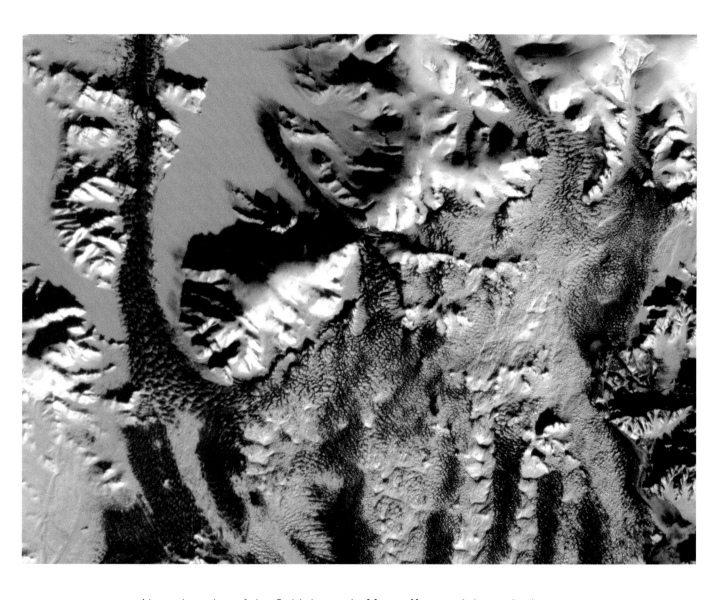

Near the edge of the Gobi desert in **Mongolia**, sand dunes look more
like the half-buried, furry remains of a tarantula.

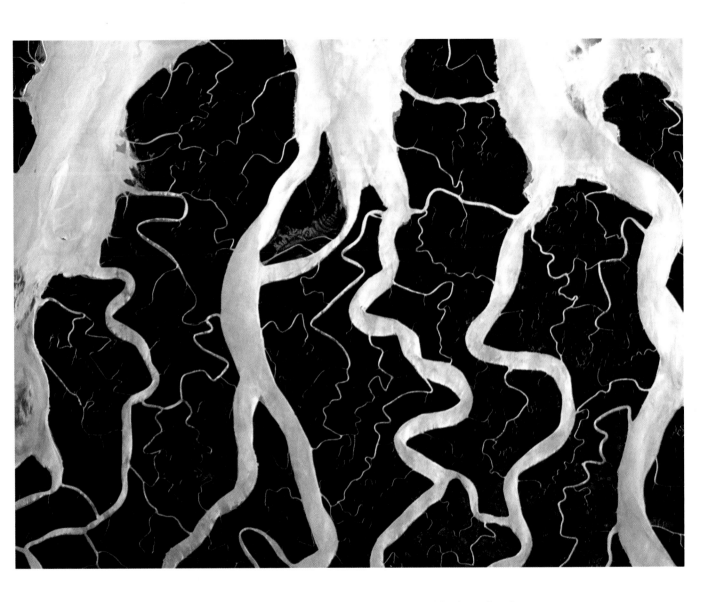

Interconnected rivers writhe through the Khulna district
of **Bangladesh** like so many strands of Medusa's hair.

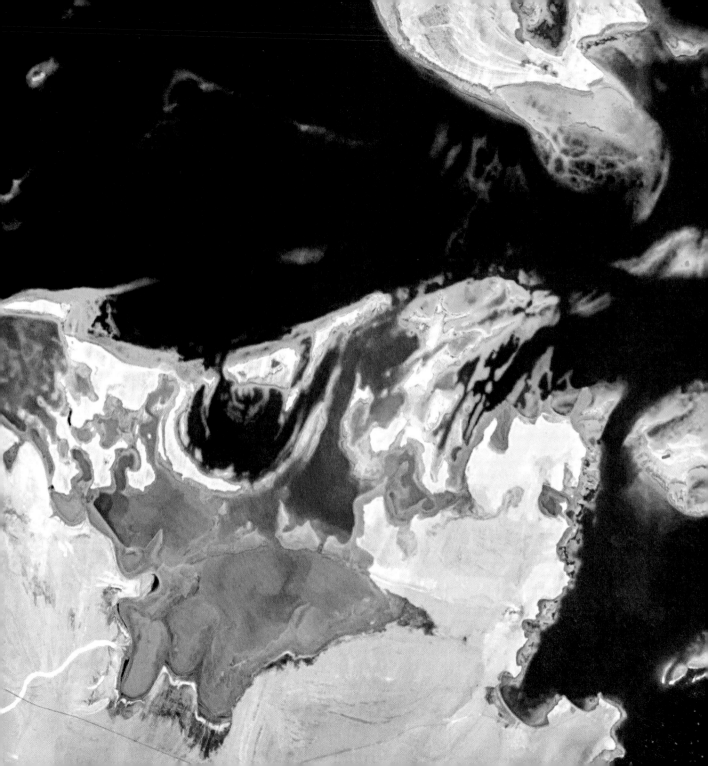

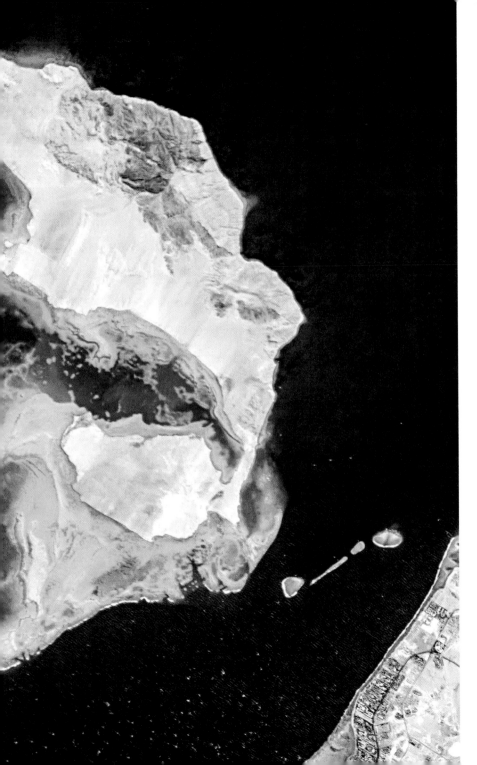

Like a colorful fish, the mouth of the Gulf of Aqaba gently sucks the tide in and out over the reefs at the tip of the Sinai peninsula near Sharm el-Sheikh, Egypt, a diver's paradise.

This is:

a.

b.

c.

d.

Answer: d. The world's largest continuous sand sea, **The Empty Quarter** covers about one-fifth of the Arabian Peninsula (and one of the planet's richest oil reserves). On the border between **Oman** and **Saudi Arabia**, towering reddish-brown dunes weave around milky salt flats known as sabhkas, remnants of ancient lakes and ponds.

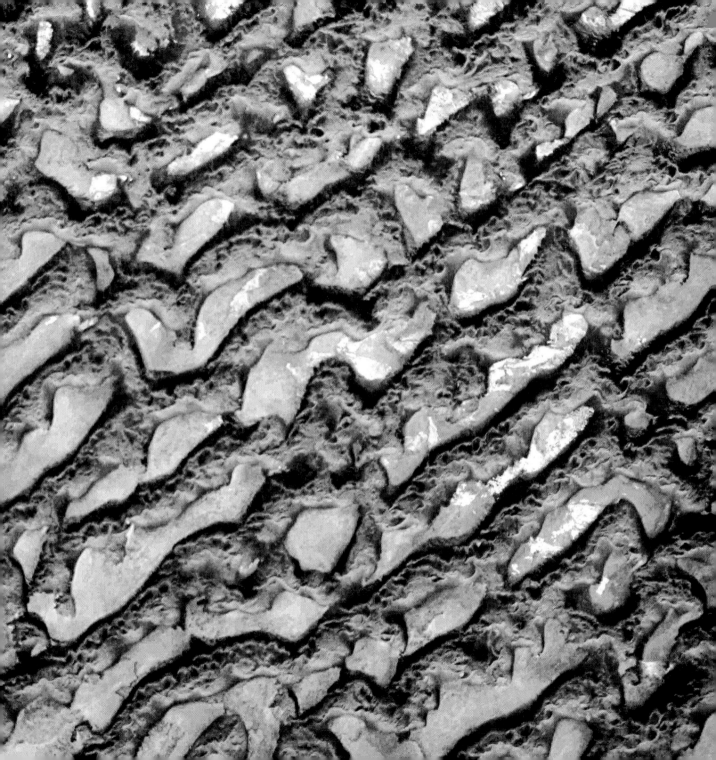

When I took this photo I was puzzled by the bridge. Why did people want to get to that brain-like blob of rock in Iran? Old satellite images answered that question: Shahi Island was once surrounded by Lake Urmia, a massive salt lake that was a retreat for flamingos and other migratory birds as well as flocks of tourists. Over the past two decades the lake has shriveled. New dams choked off the water supply upstream, new wells depleted the groundwater, and climate change further accelerated evaporation. Today, 90 percent of the water is gone, Shahi is no longer an island but a peninsula, and the birds and holiday-makers have moved on.

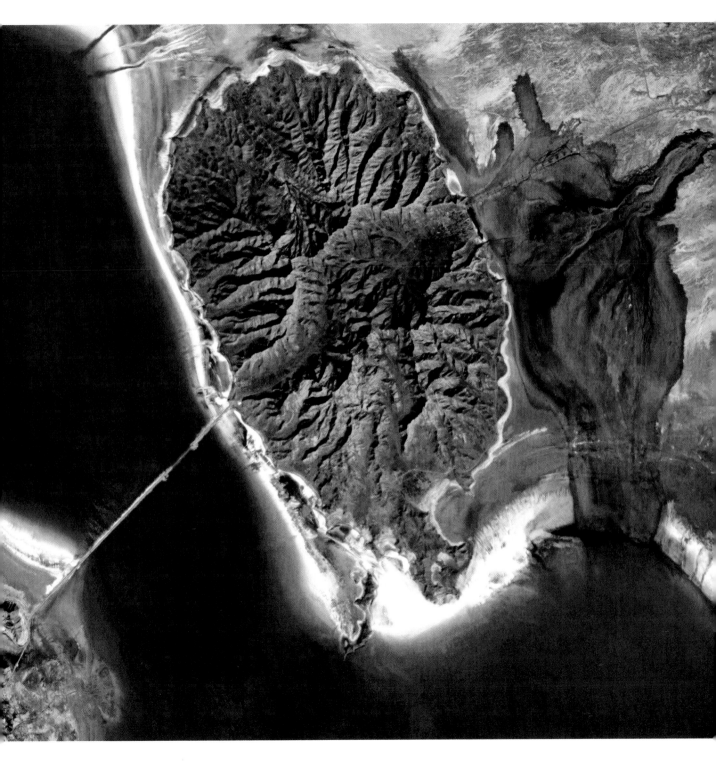

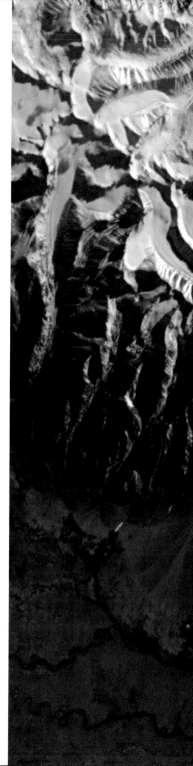

HIMALAYAS —
2 VIEWS

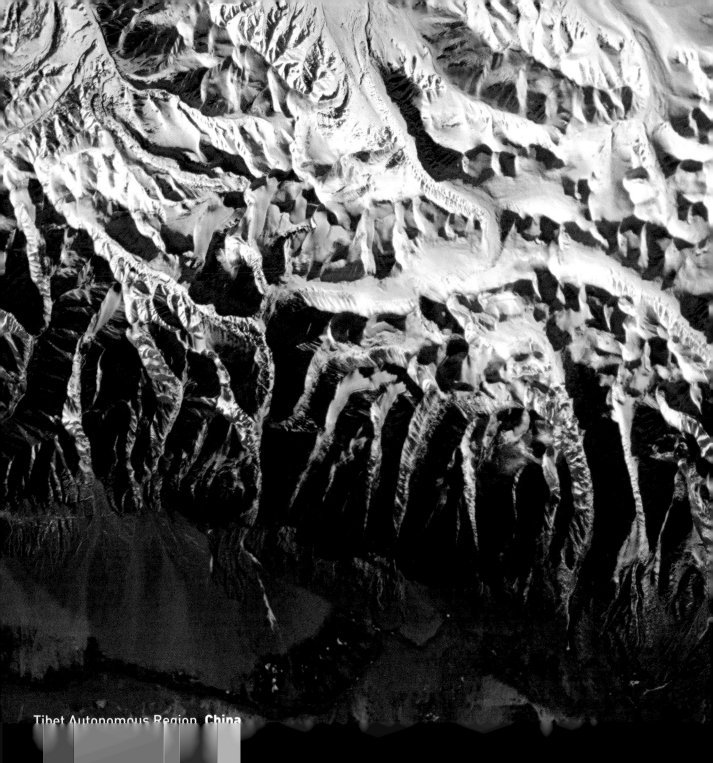

Tibet Autonomous Region, **China**

Punctuation*

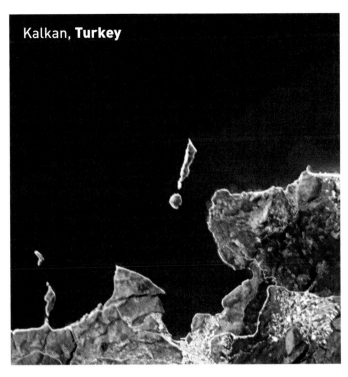

Kalkan, **Turkey**

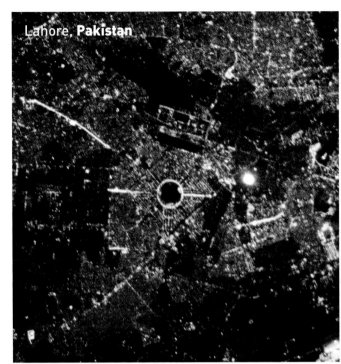

Lahore, **Pakistan**

Farms in **Saudi Arabia**

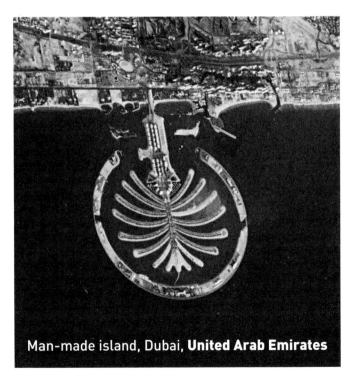

Man-made island, Dubai, **United Arab Emirates**

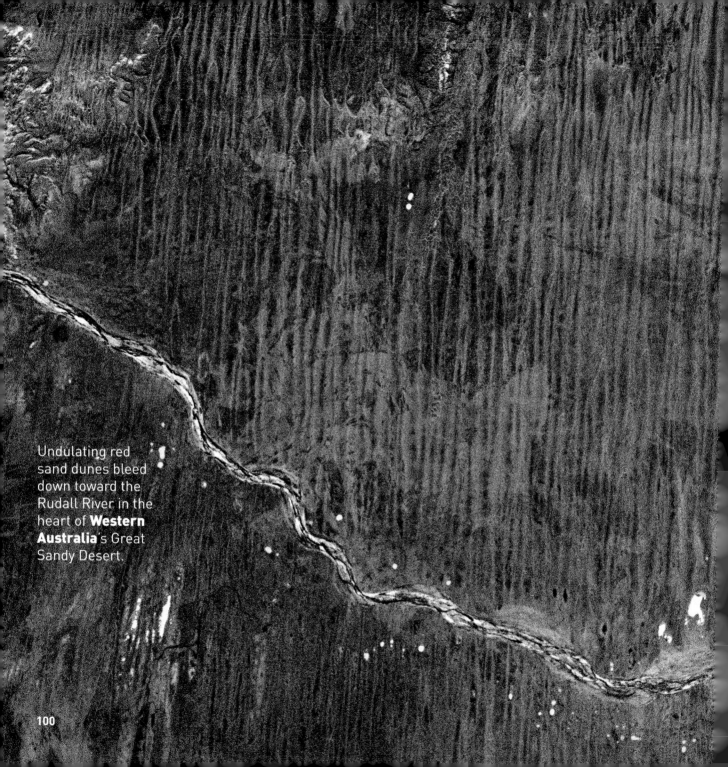

Undulating red sand dunes bleed down toward the Rudall River in the heart of **Western Australia**'s Great Sandy Desert.

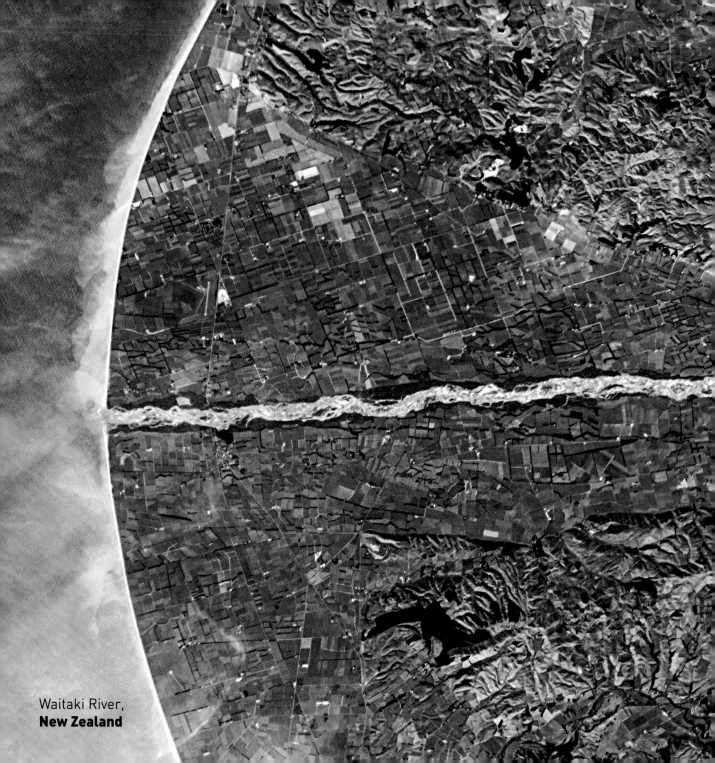

Waitaki River,
New Zealand

The region of Oceania—Australia, New Zealand and about 10,000 islands scattered across the Pacific like clumps of damp confetti—is a study in extremes: our planet's most riotously colorful and least densely populated patches are here, along with the most arid inhabited continent and the most fragile coral atolls.

Average
daily high,
January:

105.1° F

Average
monthly
precipitation,
January:

1.9"

Estimated
number of
feral camels:

100,000

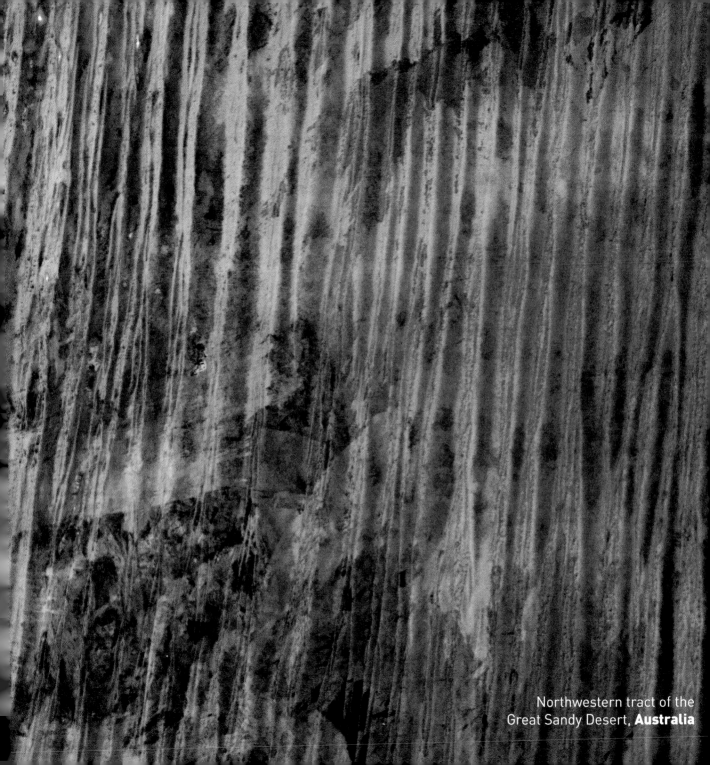

Northwestern tract of the
Great Sandy Desert, **Australia**

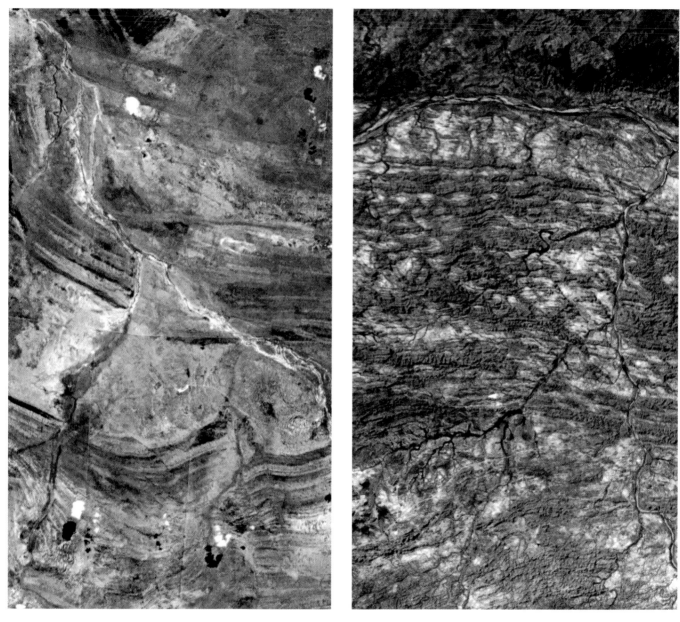

Two-thirds of Australia is covered in sparsely populated deserts and semi-arid plains, flattened by erosion and baked by the sun. These two shots of the Great Sandy Desert in **Western Australia** show-case its surprising and apparently infinite variety: swirls of green in the north, close to the coast (and more rain), give way to scorched rusty rocks and parched riverbeds just a few hundred miles away.

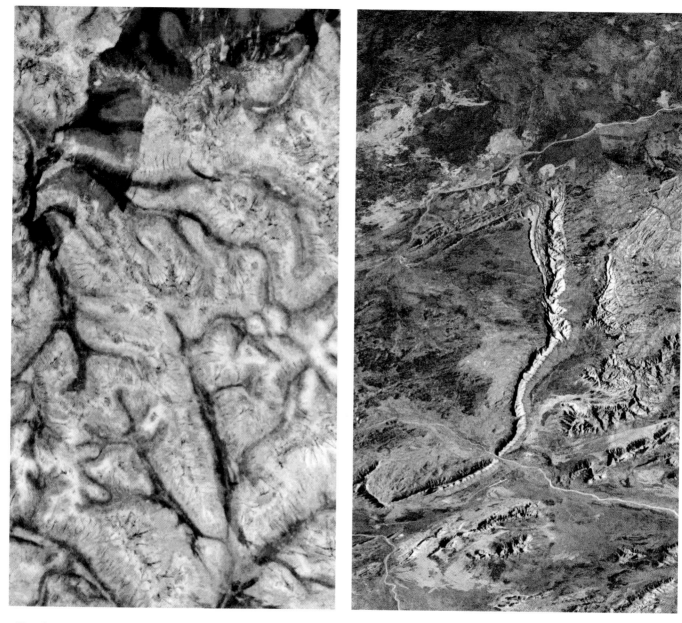

Further south, labyrinthine stream beds run like veins through rounded red dunes in the Gibson Desert; hummocks of bluish and green grass soften the hills here. Further east, in the **Northern Territory**, a spiny ridge pokes up, apparently the toughest, most disrespectful remnant of the mountains that dominated Australia millions of years ago, still daring the harsh climate to try to grind it down.

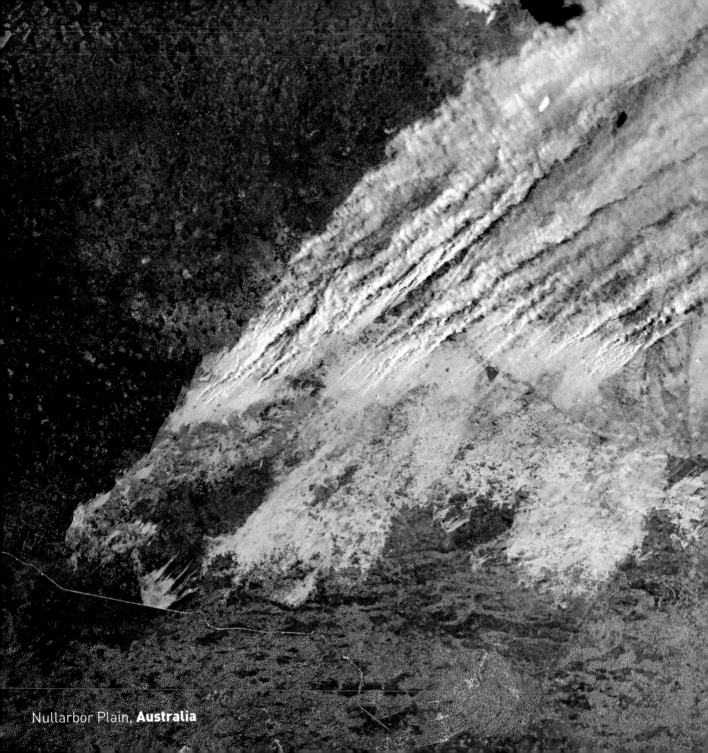

Nullarbor Plain, **Australia**

Summer bushfires, sparked by extreme heat and dryness, sear new scars on dry plains. On average, there are 50,000 bushfires a year in Australia—a cycle of devastation (and regeneration) that is millions of years old.

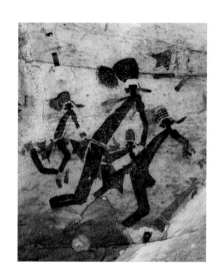

Rock paintings in **Australia** are among the oldest on the planet, with some confirmed to date back at least 28,000 years. Called Gwion Gwion figures, many mirror the colors and shapes of the landscape so closely that they almost seem to have been inspired by an aerial view of the Outback. Perhaps they were: Gwion Gwion was, according to aboriginal cosmology, a long-beaked bird before he morphed into a human artist.

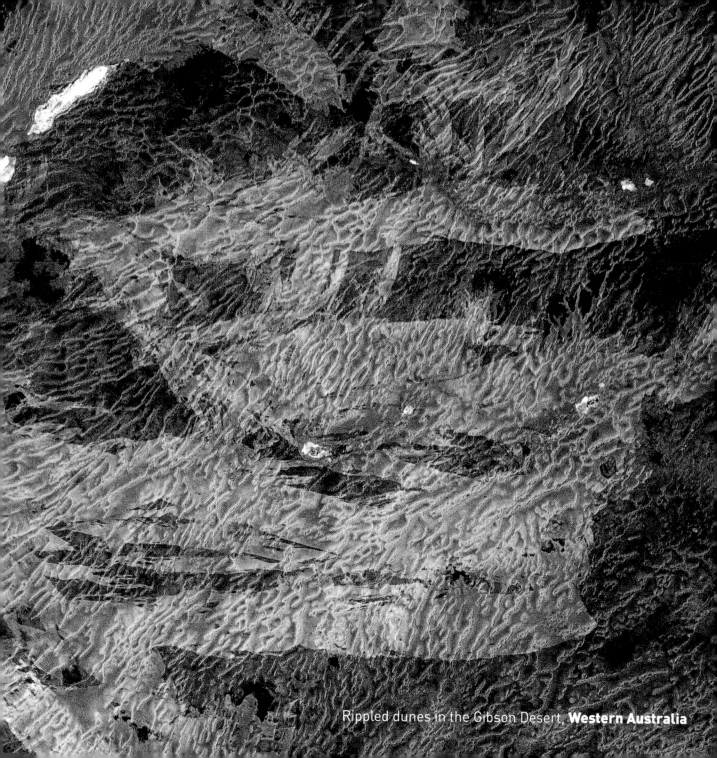

Rippled dunes in the Gibson Desert, **Western Australia**

TONGAREVA

THE LARGEST AND MOST REMOTE
OF THE COOK ISLANDS. MAXIMUM
ELEVATION: 16' ABOVE SEA LEVEL.

POPULATION 2001: 351
POPULATION 2011: 213

About one-third of **New Zealand**'s population lives in Auckland, which centers on this slender isthmus. No surprise that one-third of all households have boats: there's a harbor on the Tasman Sea, to the west, and another on the Pacific, to the east. Looks idyllic, but this is the ring of fire. Evidence of the violent nature of New Zealand's birth is all around: more than 50 extinct volcanoes and jagged piles of rock of varying ages attest to tectonic activity—ongoing, since New Zealand sits on top of two plates, which clank uneasily underneath the turquoise water.

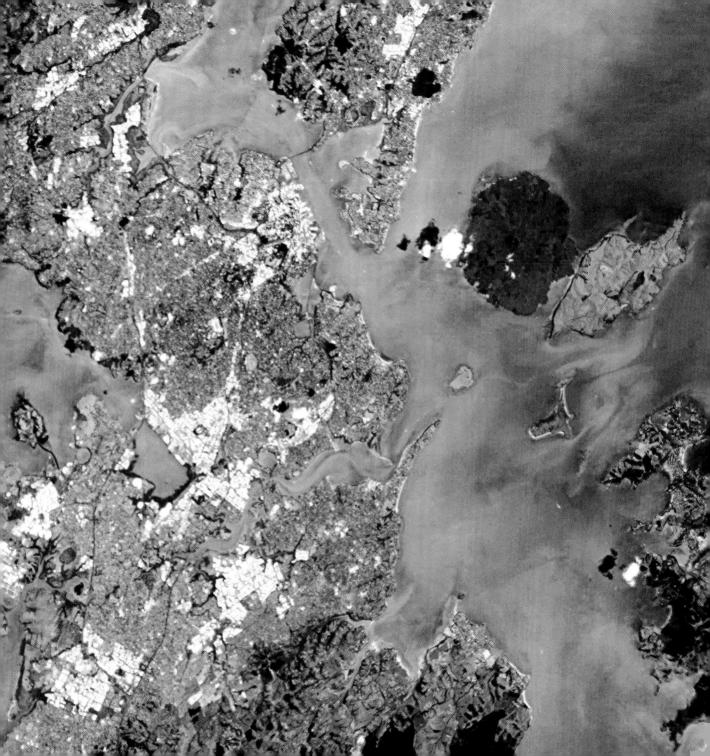

 For more than 150 years New Zealand's Mount Taranaki has been sleeping quietly, eye wide open. In the meantime, humans dealt with the unpredictable wildness of the volcano by cinching it with a belt of heavily forested parkland. The paler green fields beyond are dairy farms that previous eruptions helped create, by spewing mud, ash and volcanic material every which way—a great basis for rich soil. From orbit, the fussy handiwork of humans—the symmetry of that circle!—looks surreal. But the purpose was sober: to maximize the chances of survival. Scientists think Taranaki is overdue for an eruption.

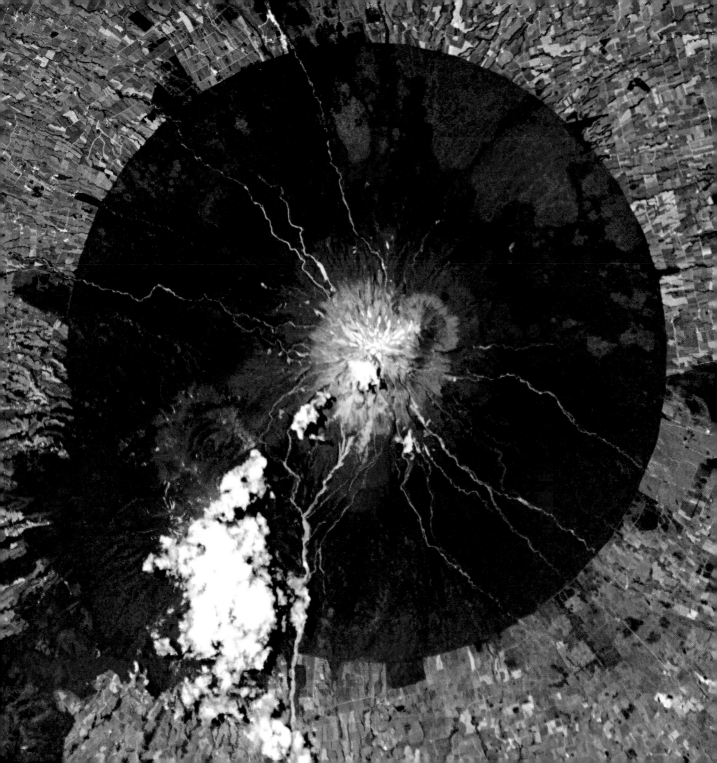

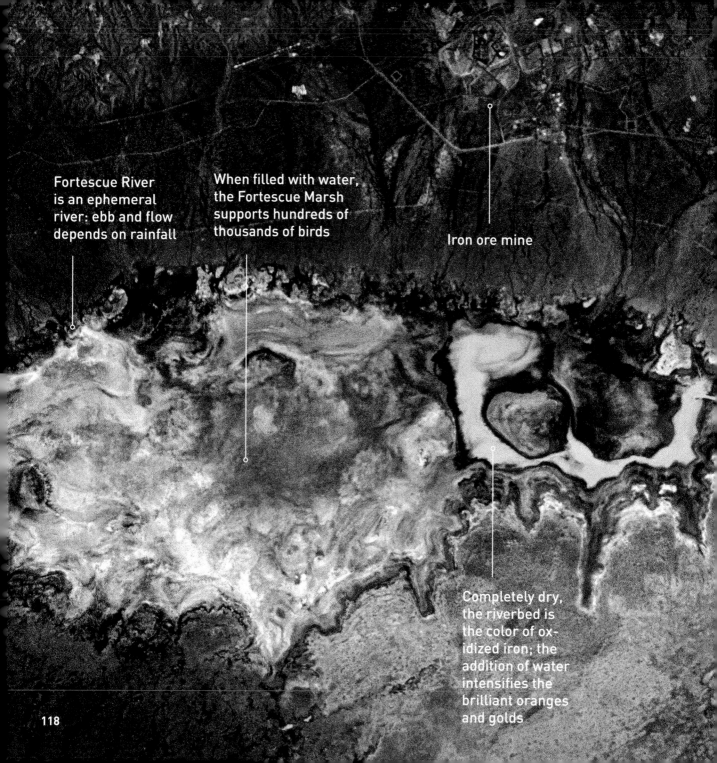

Fortescue River is an ephemeral river: ebb and flow depends on rainfall

When filled with water, the Fortescue Marsh supports hundreds of thousands of birds

Iron ore mine

Completely dry, the riverbed is the color of oxidized iron; the addition of water intensifies the brilliant oranges and golds

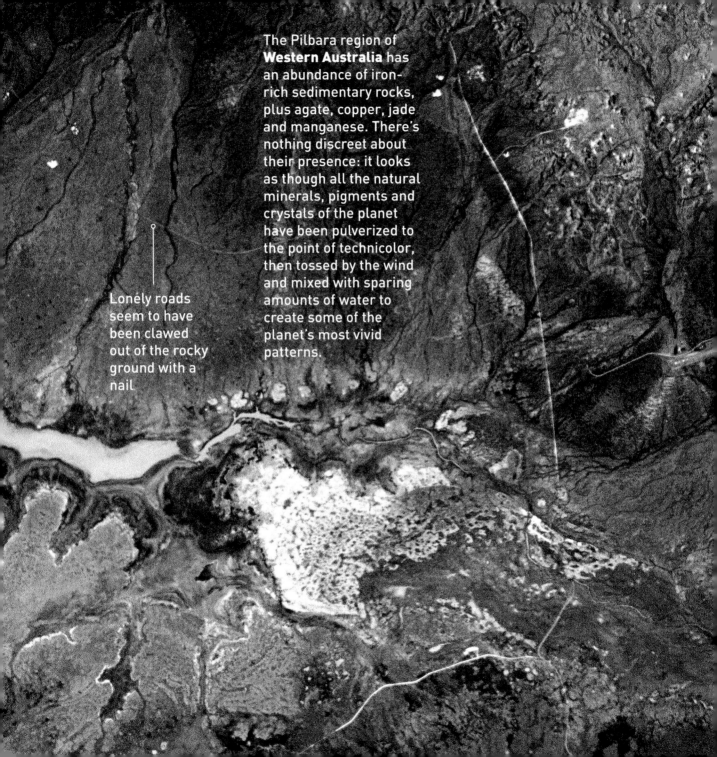

The Pilbara region of **Western Australia** has an abundance of iron-rich sedimentary rocks, plus agate, copper, jade and manganese. There's nothing discreet about their presence: it looks as though all the natural minerals, pigments and crystals of the planet have been pulverized to the point of technicolor, then tossed by the wind and mixed with sparing amounts of water to create some of the planet's most vivid patterns.

Lonely roads seem to have been clawed out of the rocky ground with a nail

Today, Broome is a popular beach town in **Western Australia**. In the late 19th century, however, pearling was the major industry—a dangerous one. More than 900 of the Japanese divers who came to Broome died while trying to harvest oysters, and are buried there; many others were lost at sea.

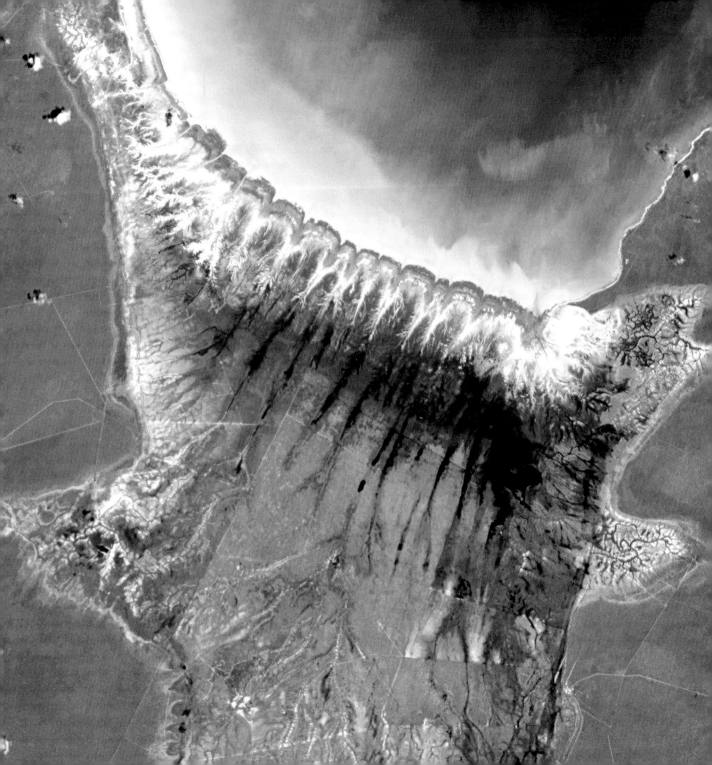

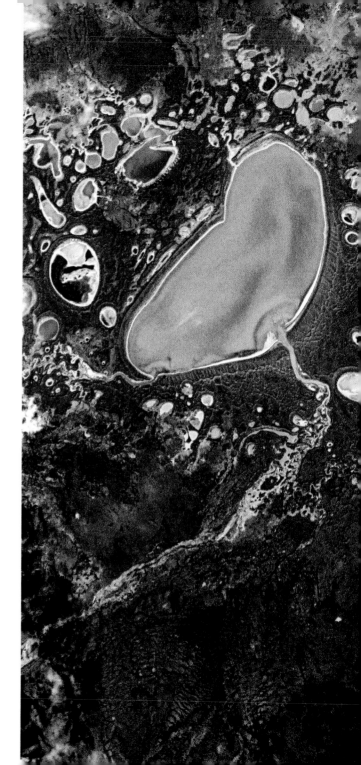

Lake Burnside looks like a classic one-cell organism, slowly boiling down to an insignificant crust of salt in **Western Australia**'s Gibson Desert. But this saline globule is actually substantial, covering about 160 square miles in a desert that's a little bigger than the state of Florida—which is to say, only the fifth largest desert on the continent.

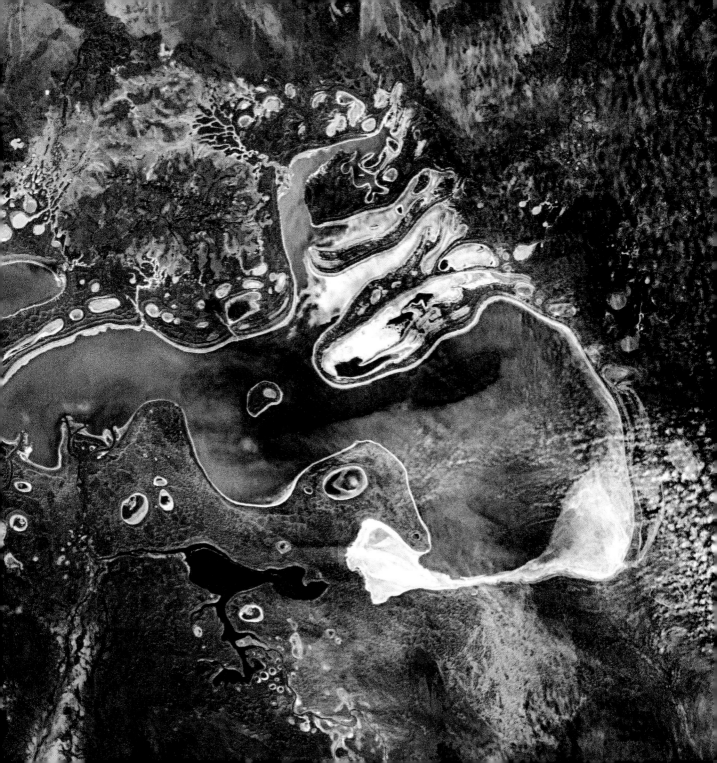

The British explorer who named Kangaroo Island in 1802 didn't circumnavigate it, or he might have chosen a different name. To be fair, there are still plenty of kangaroos, and it's one of the most popular wild-life destinations in Australia.

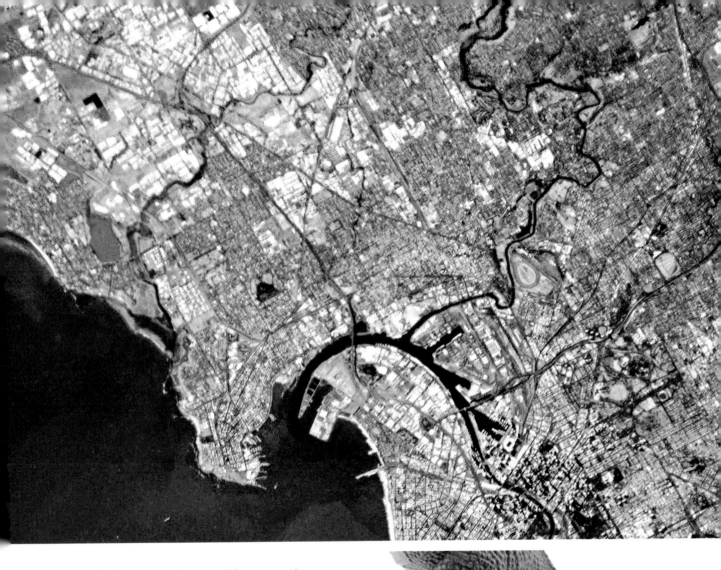

In Melbourne, **Australia**, creating channels and docks to accommodate large ships dramatically altered the course of the Yarra River. The port is now the continent's busiest, but maybe the ambitious planners had a cosmic sense of humor, too.

Clouds sprinkled like I^CING SUG^AR on the limestone bedrock of Nullarbor, on the Great Australian Bight coast

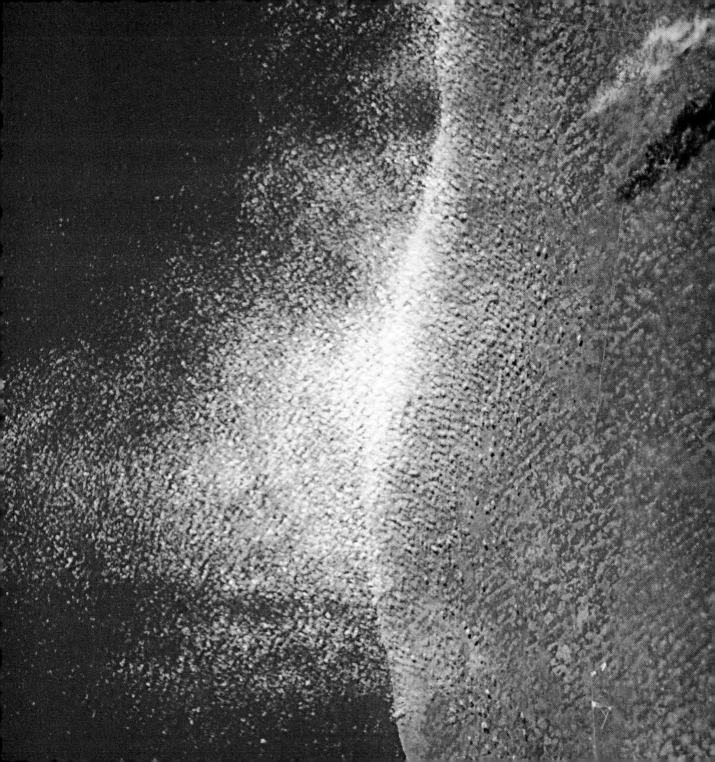

Even if the lights of San Francisco weren't visible, this could only be North America, the one continent with enough coast-to-coast plane traffic to create cross-hatched contrails (not pollution but streams of water vapor left behind by jets). From space, these trails are rare and reassuring evidence of real-time human activity below.

North America

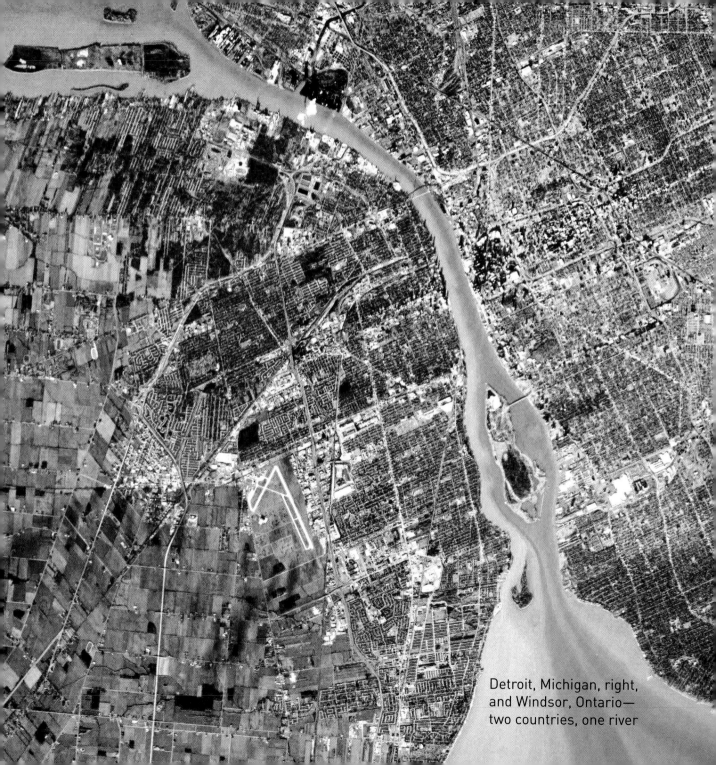

Detroit, Michigan, right,
and Windsor, Ontario—
two countries, one river

The human impulse to impose order on Nature is apparent everywhere in North America, from the right angles of modern agriculture to the precise grids of some of the planet's youngest cities, yet there are still vast tracts of virtual wilderness— new frontiers, unruly and untouched.

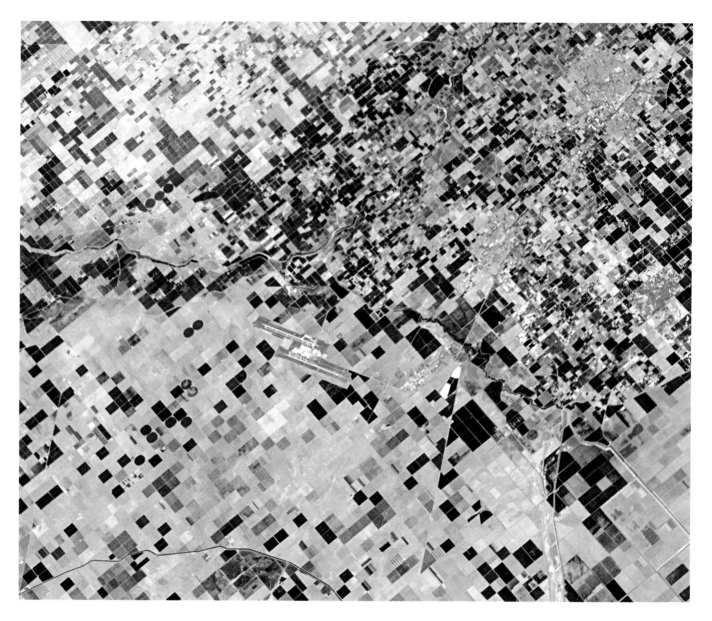

Humans make art unintentionally: in **California**'s San Joaquin Valley, which bills itself as the world's bread-basket, one group drew irrigation lines, another handled property lines, a third carved out county lines, creating a graphic, pixelated pattern. Those two huge, offset runways belong to Naval Air Station Lemoore—nowhere near water—where I learned to fly A7s before becoming a U.S. Navy test pilot.

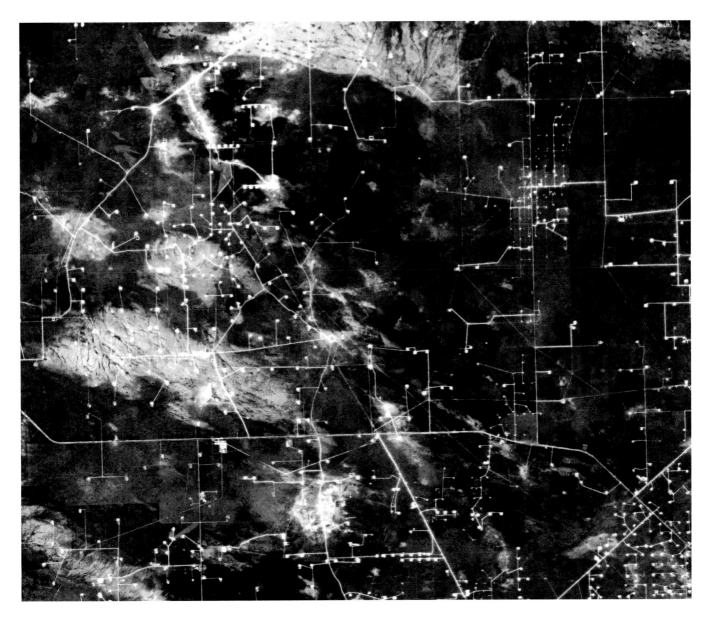

Oil and gas sites light up the brown, scrubby land around Carlsbad, **New Mexico**, like a circuit board. Each dot marks a place where someone is drilling or mining, hoping to hit a sweet spot in the petroleum- and potash-rich Permian Basin. The result is an illuminated map, highlighting the precise locations where human ambition has been (or hopes to be) rewarded with subterranean treasure.

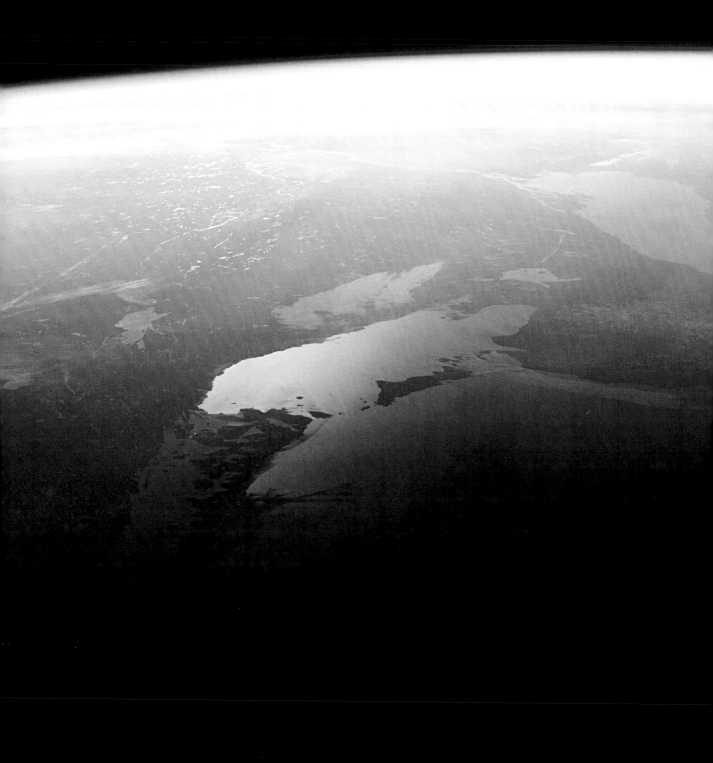

The Great Lakes
20% of the world's fresh water

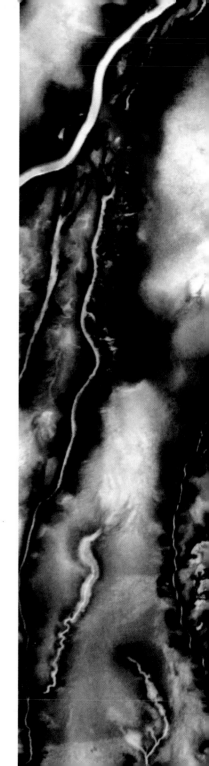

These squiggly striations near Moosonee in northern **Ontario** are streams and small rivers feeding into the Moose River, which in turns empties into James Bay, the huge, southern end of Hudson Bay, which connects to the Arctic Ocean. It's cold but humans have been living here almost since the last glacier retreated, about 8,000 years ago. Today, Moosonee is where the railroad ends and goods are moved onto ships and planes for transport to the Far North, a land of no roads and no trees, but lots of water, ice and snow.

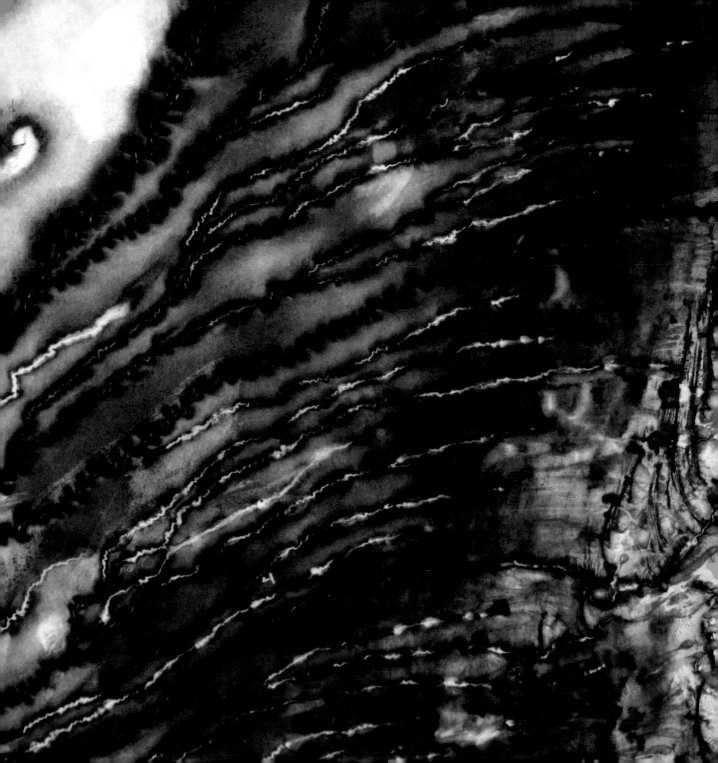

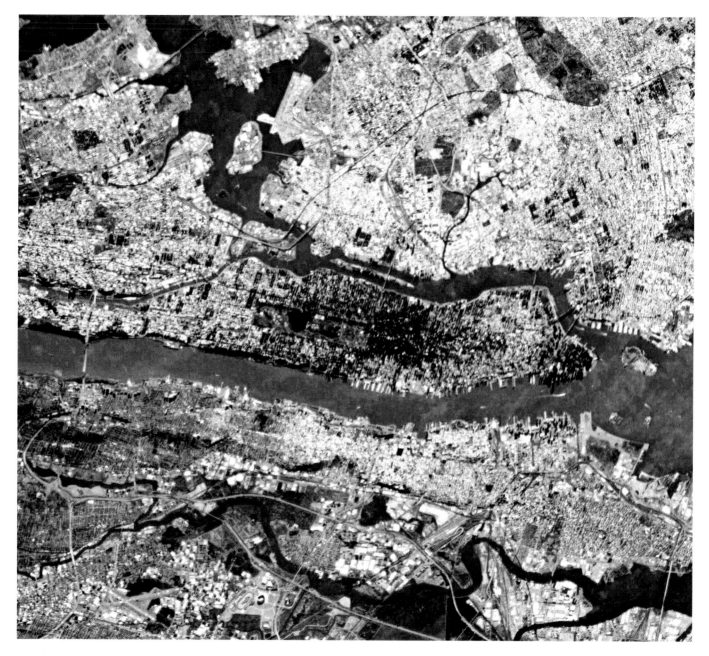

Manhattan awake, 9:23 a.m. local time

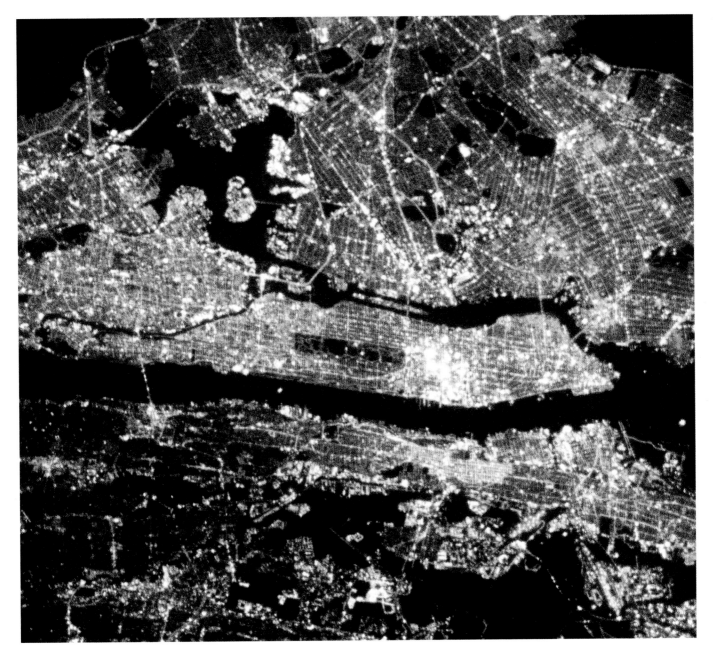

Manhattan at rest, 3:45 a.m. local time

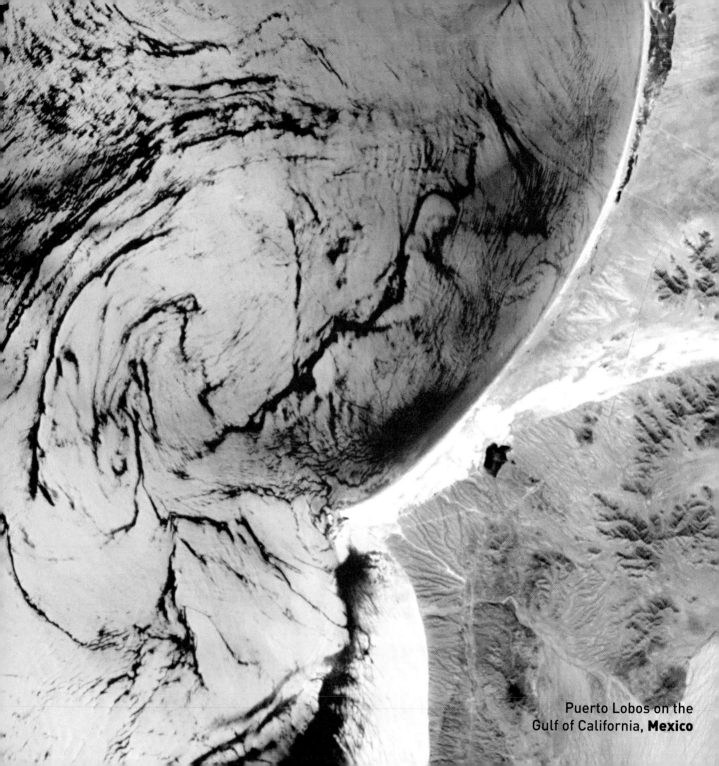

Puerto Lobos on the
Gulf of California, **Mexico**

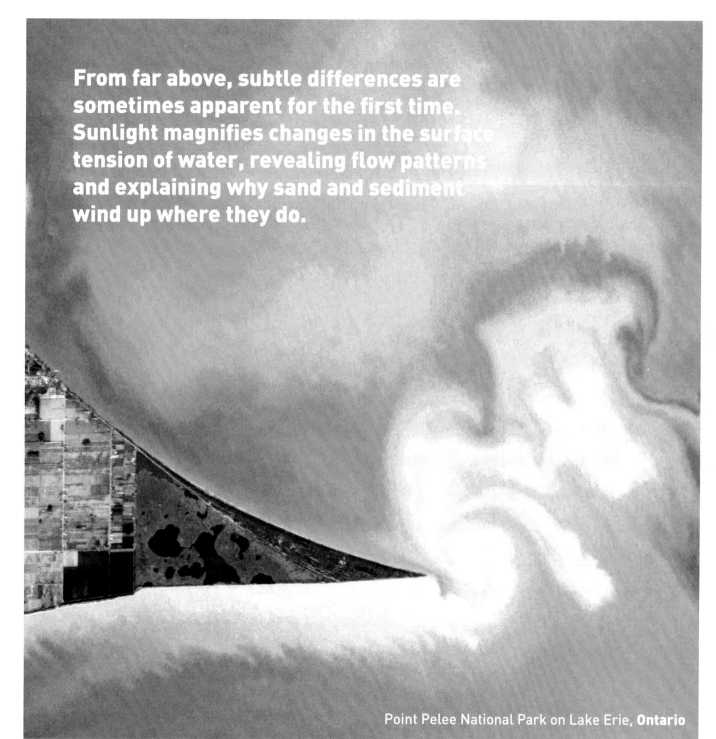

From far above, subtle differences are sometimes apparent for the first time. Sunlight magnifies changes in the surface tension of water, revealing flow patterns and explaining why sand and sediment wind up where they do.

Point Pelee National Park on Lake Erie, **Ontario**

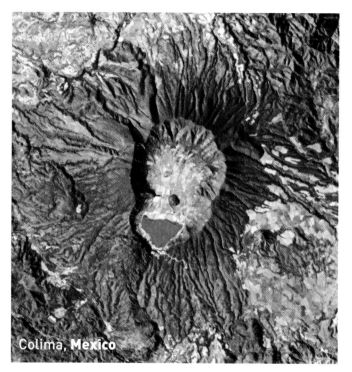

Colima, **Mexico**

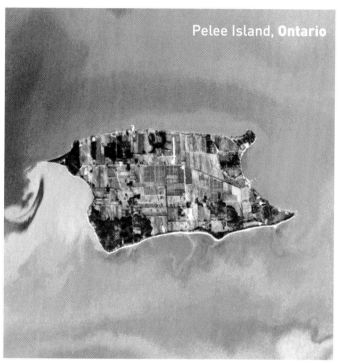

Pelee Island, **Ontario**

Chatter

Oink

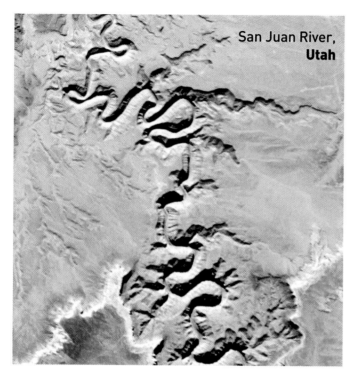

San Juan River,
Utah

Slither

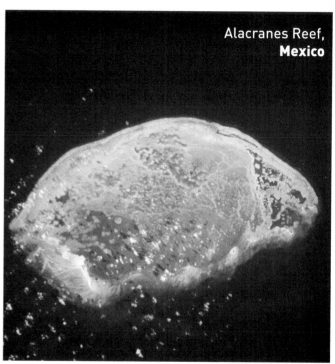

Alacranes Reef,
Mexico

Sting

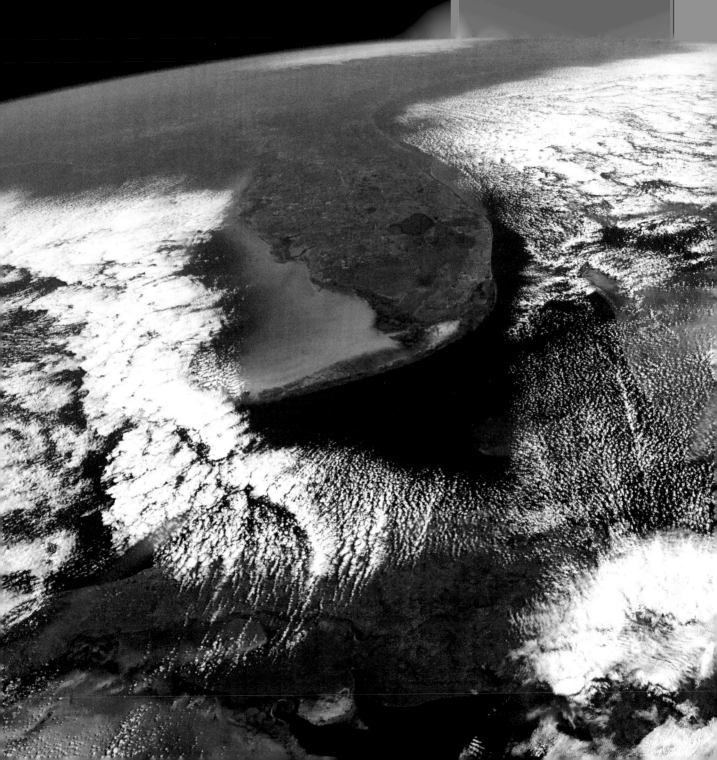

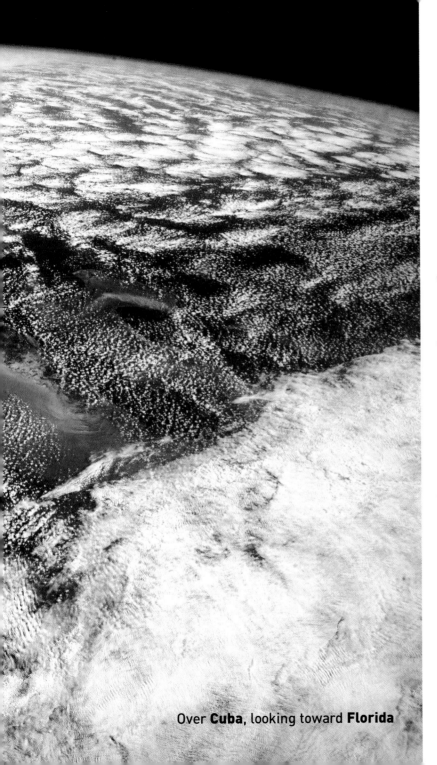

Over **Cuba**, looking toward **Florida**

On a clear day you can see forever (or at least from Havana to Washington, D.C.).

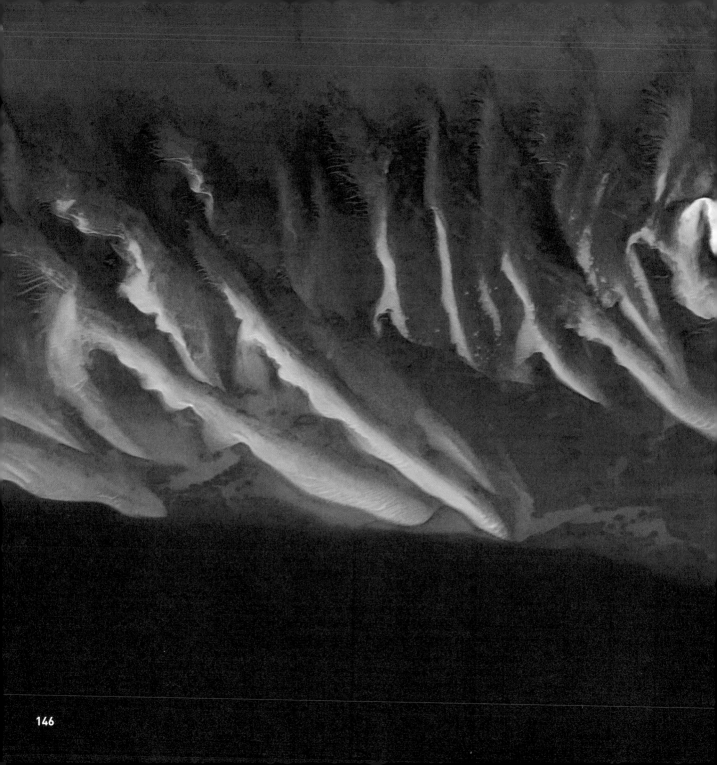

146

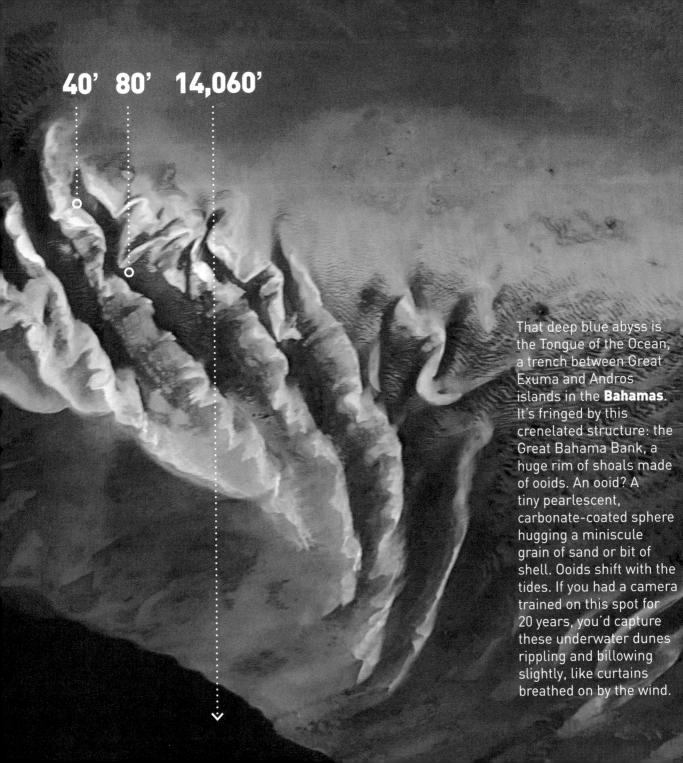

40' 80' 14,060'

That deep blue abyss is the Tongue of the Ocean, a trench between Great Exuma and Andros islands in the **Bahamas**. It's fringed by this crenelated structure: the Great Bahama Bank, a huge rim of shoals made of ooids. An ooid? A tiny pearlescent, carbonate-coated sphere hugging a miniscule grain of sand or bit of shell. Ooids shift with the tides. If you had a camera trained on this spot for 20 years, you'd capture these underwater dunes rippling and billowing slightly, like curtains breathed on by the wind.

TORONTO, UNDER
FRESH SNOW

I LIVE HERE

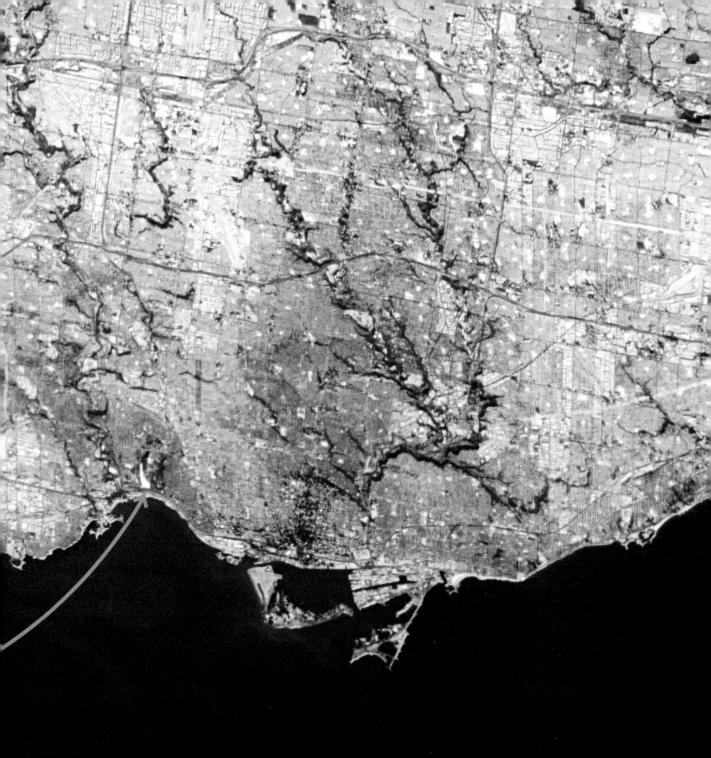

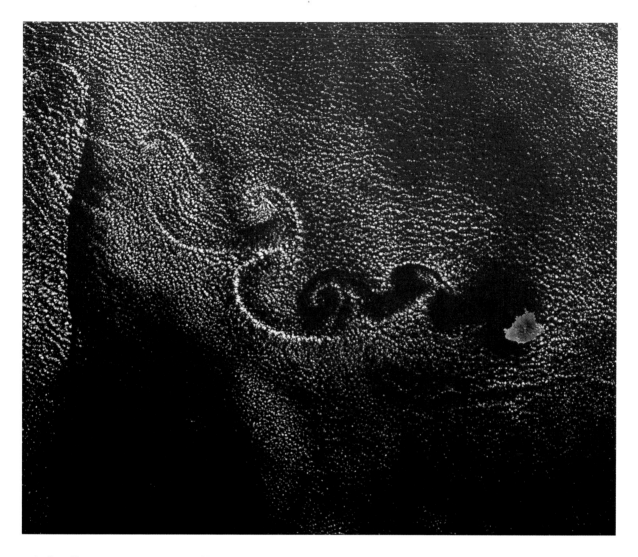

Isla Socorro, a small volcanic island about 375 miles off **Mexico**'s west coast, sparks these paisley spiral clouds, called von Kármán vortices. They occur when a prevailing wind hits an obstacle like an island, which disturbs the flow of air, sending the clouds reeling downwind in long chains of eddies. Theodore von Kármán, the physicist who first explained the phenomenon, was one of the founders of NASA's jet propulsion lab.

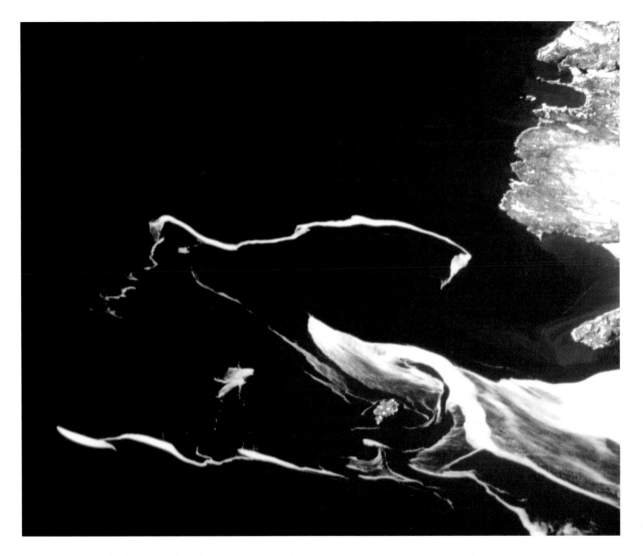

It's surprising to look down and see what appears to be a seal drawn by Dr. Seuss—especially when it's made out of something as transient as sea ice. This seal seemed ready to swallow tiny St. Paul Island, just on the edge of the Gulf of St. Lawrence, off **Nova Scotia**. But St. Paul, uninhabited and often fogbound, is known as "the Graveyard of the Gulf"—and so it was for the ice seal, which split apart on either side, as have many ships over the years.

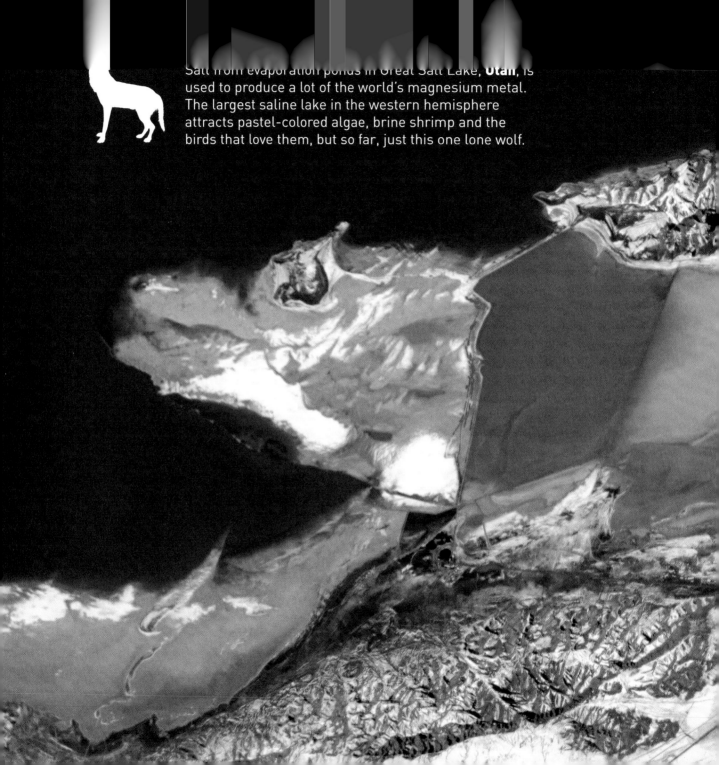

Salt from evaporation ponds in Great Salt Lake, **Utah**, is used to produce a lot of the world's magnesium metal. The largest saline lake in the western hemisphere attracts pastel-colored algae, brine shrimp and the birds that love them, but so far, just this one lone wolf.

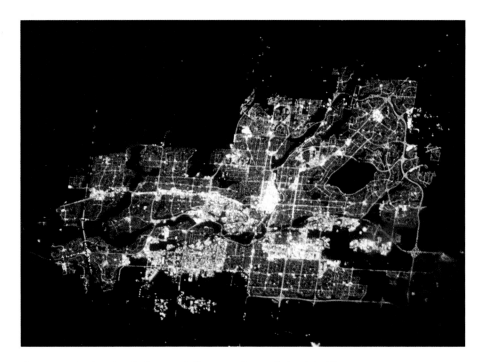

Coyotes thrive in Calgary, **Alberta**, Canada's third largest city, partly thanks to the unmanicured natural environment of Nose Hill Park, that dark unlit space—more than three times the size of Central Park—in the city's center.

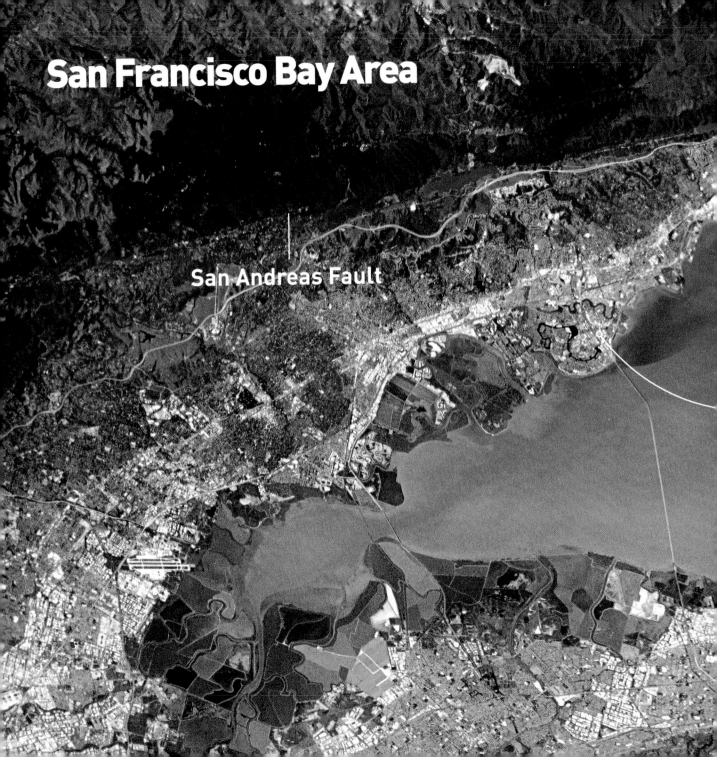

San Francisco Bay Area

San Andreas Fault

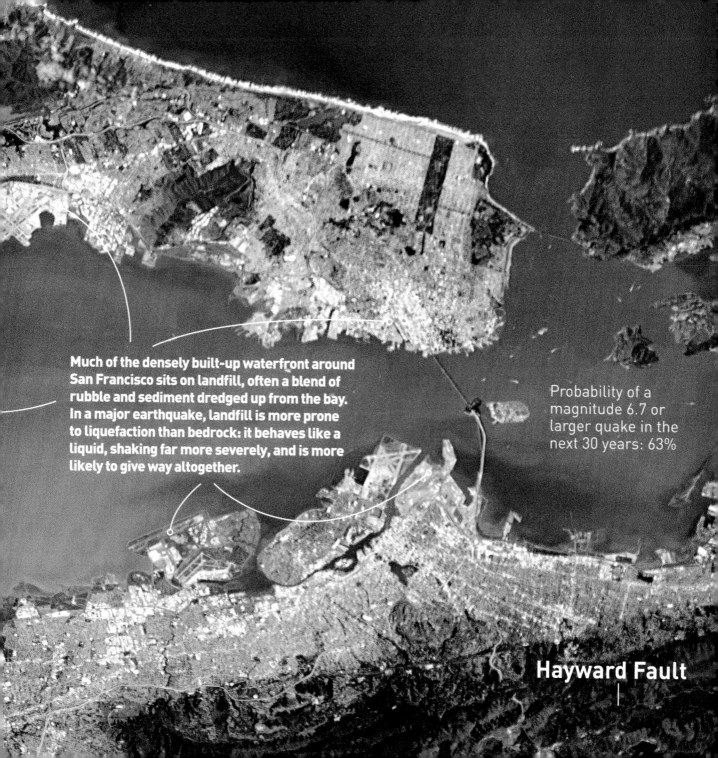

Much of the densely built-up waterfront around San Francisco sits on landfill, often a blend of rubble and sediment dredged up from the bay. In a major earthquake, landfill is more prone to liquefaction than bedrock: it behaves like a liquid, shaking far more severely, and is more likely to give way altogether.

Probability of a magnitude 6.7 or larger quake in the next 30 years: 63%

Hayward Fault

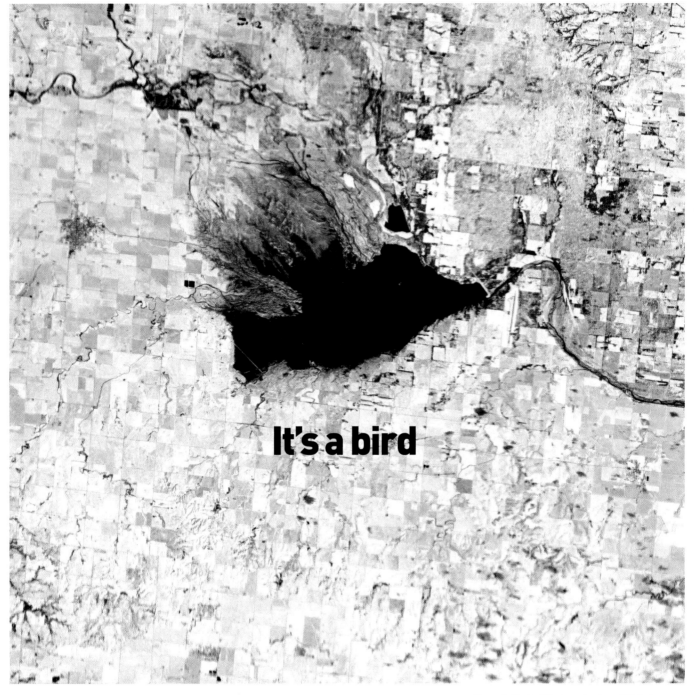

It's a bird

Great Salt Plains Lake, **Oklahoma**

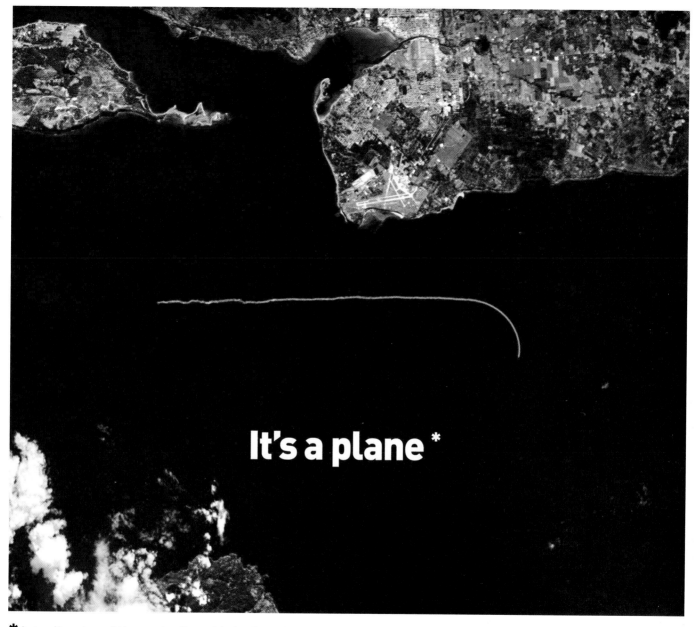

It's a plane *

*Actually, nine of them: the Snowbirds, Canada's military aerobatic team, wondered if they were visible from space. I was doubtful, but we set up a time when they'd be practicing near Comox, **British Columbia**, flying abreast to create the maximum trail. I woke in the middle of the night (the ISS is on Greenwich Mean Time) to see this line being drawn on the sky. It was magical—usually, Earth looks like a still life. And evocative: I've flown an F-86 on the Snowbirds' wing, so I knew exactly how they felt holding formation as they made that turn.

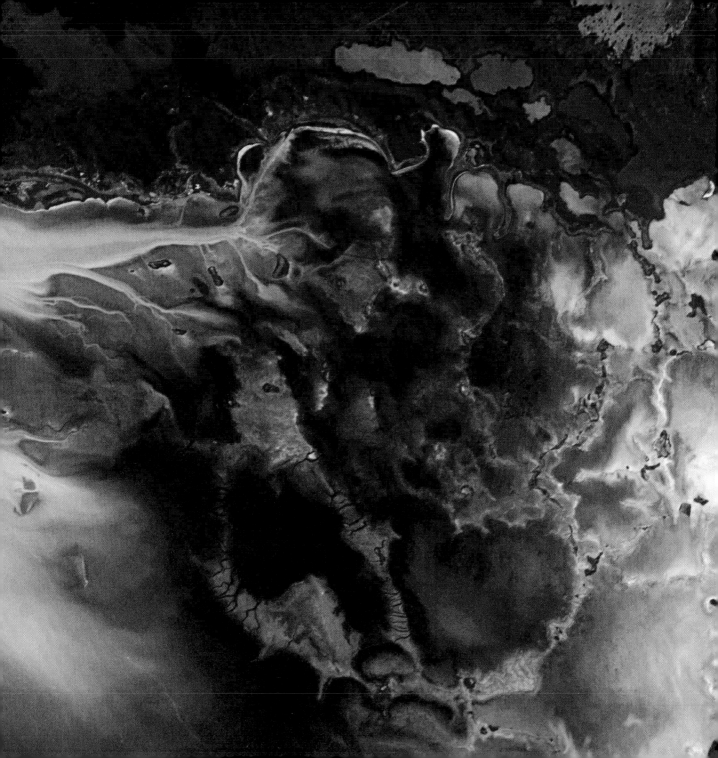

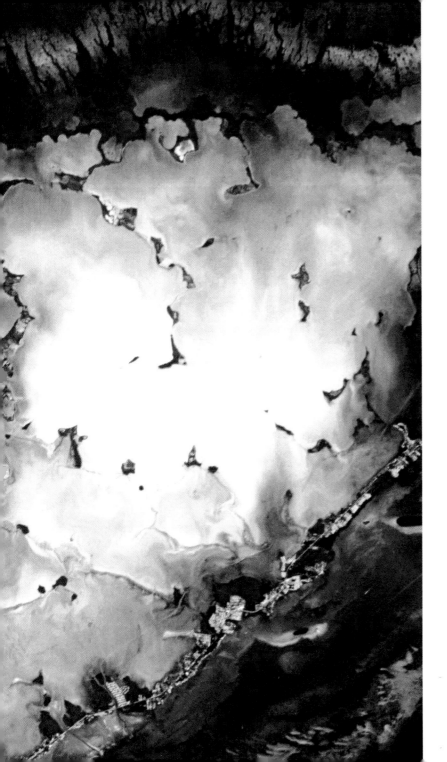

The empty murk of the Everglades gives way to the milky blue shallows and tattered lace of the Florida Keys.

Landscape and land use patterns tend to be so similar on both sides of an international border that from orbit, it's impossible to distinguish one country from another. The line between **Mexico** and the **United States**, however, is readily apparent in several places. Here's one: Tijuana presses up against the border separating it from San Diego, which is greener and much less densely populated. The cities share the same climate and topography, but while the line between them may have been drawn arbitrarily, it is not imaginary.

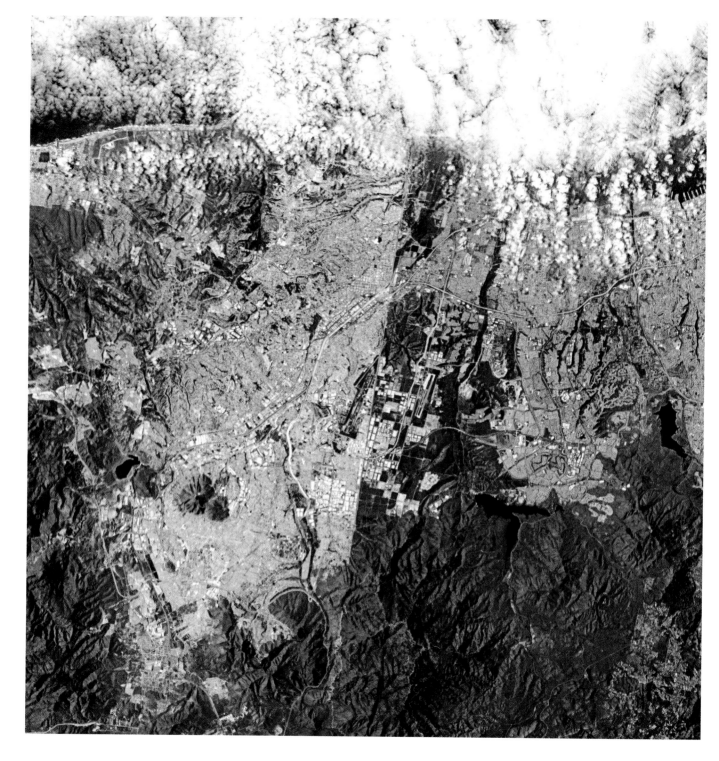

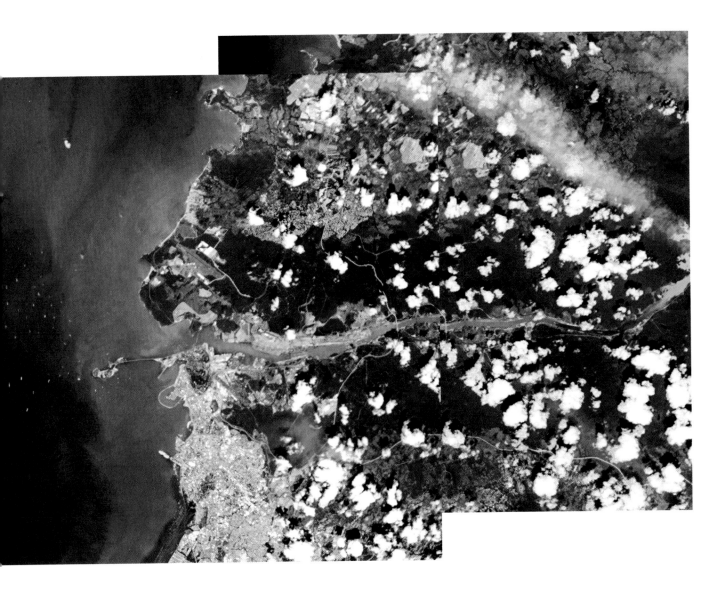

A fleet of ships on the Pacific Ocean side of the Panama Canal, waiting to traverse the 48-mile ribbon of water through the Isthmus of **Panama** and out to the Atlantic Ocean.

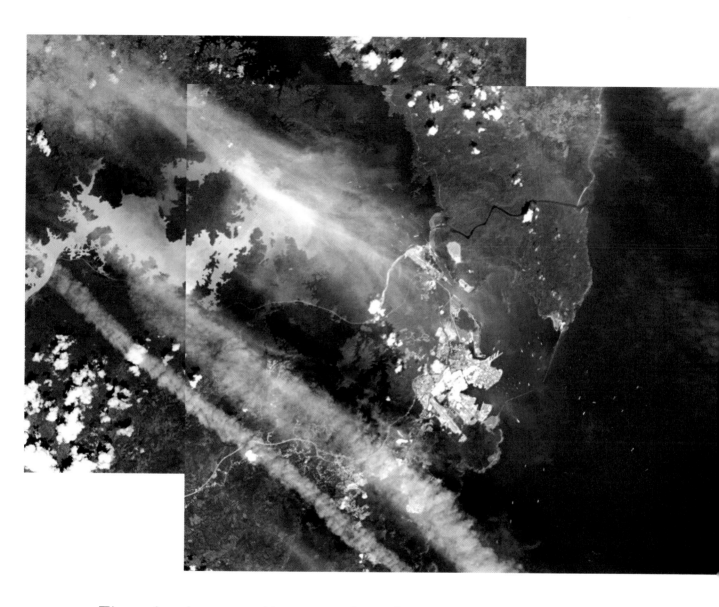

There's always a line-up of cruise and cargo ships on the Atlantic side, too. The other option—sailing around Cape Horn— is about 8,000 nautical miles longer.

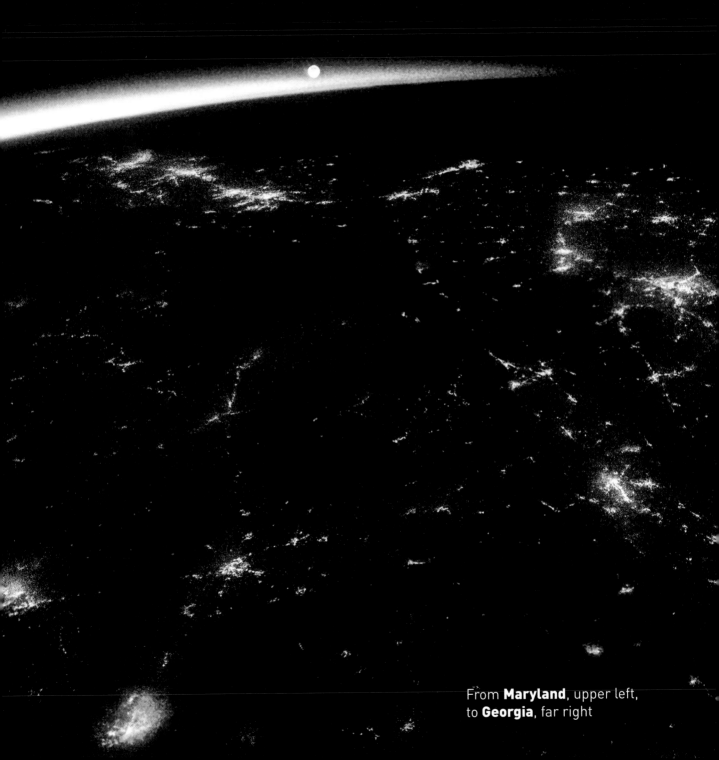

From **Maryland**, upper left,
to **Georgia**, far right

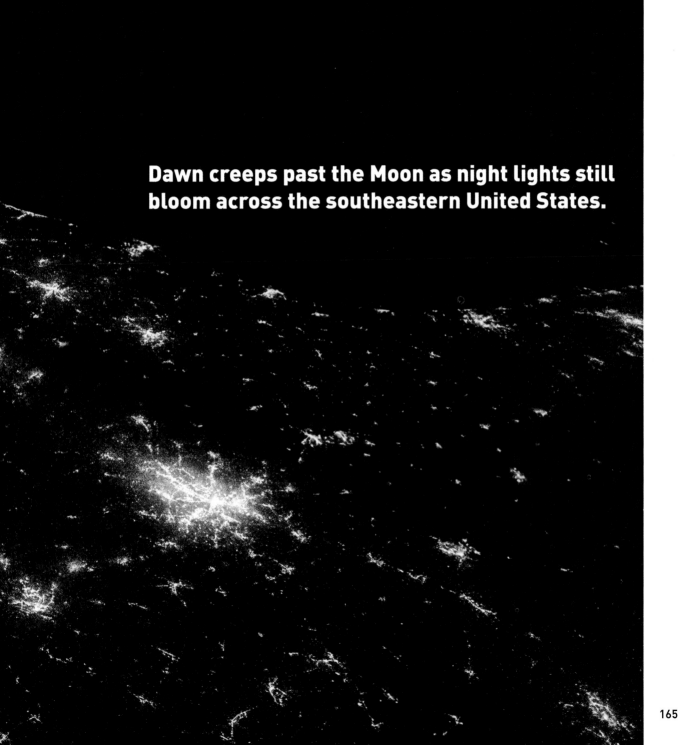

Dawn creeps past the Moon as night lights still bloom across the southeastern United States.

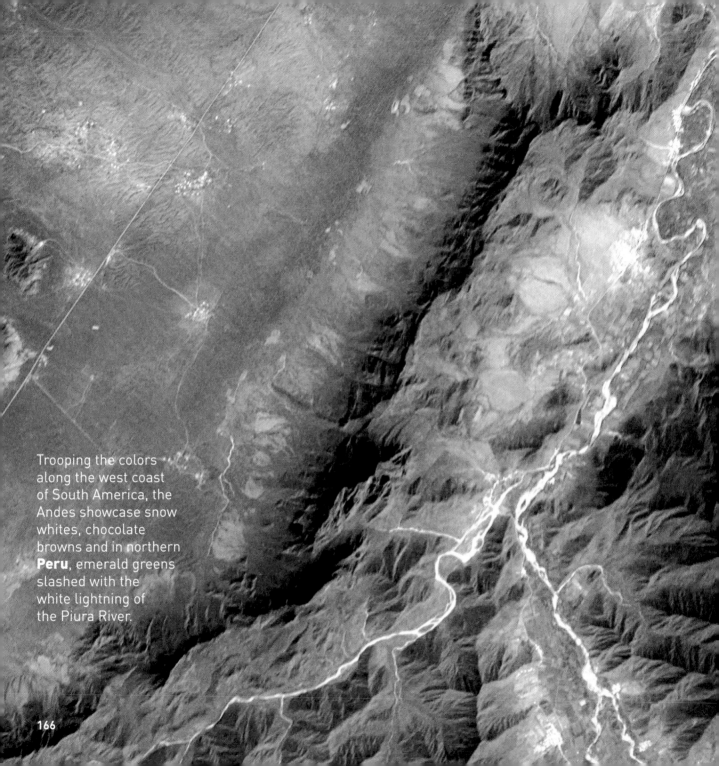

Trooping the colors along the west coast of South America, the Andes showcase snow whites, chocolate browns and in northern **Peru**, emerald greens slashed with the white lightning of the Piura River.

South America

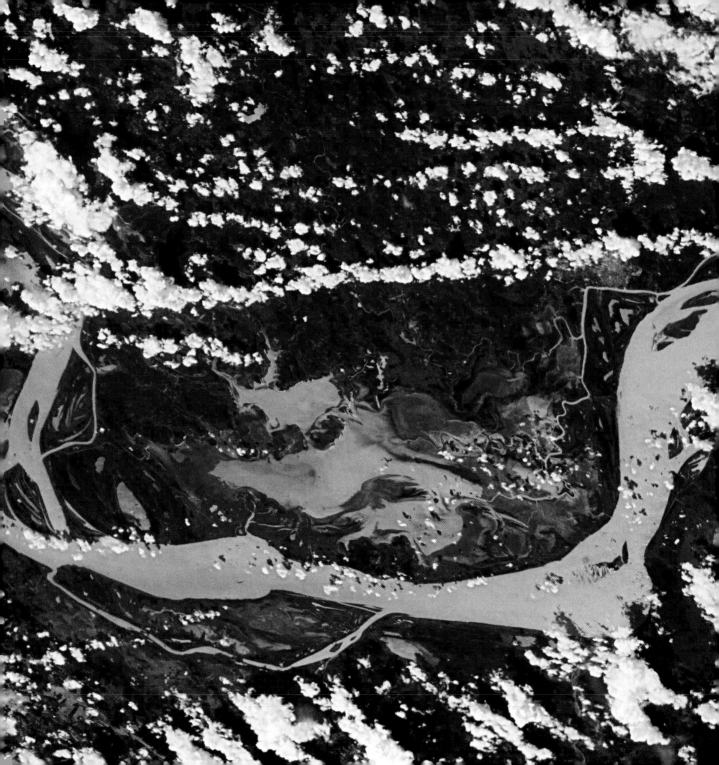

The Amazon River Basin, the largest in the world, creates a lush green blanket that covers about one-third of South America, stitched unevenly with winding brown rivers and bordered with the jagged peaks of the Andes—a continent of repeating patterns and exaggerated contradictions.

The Amazon near Monte Alegre, **Brazil**

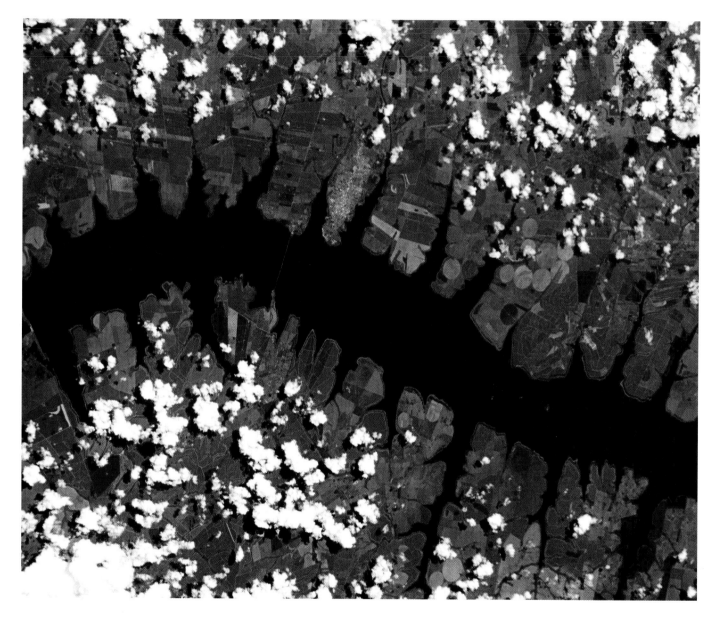

The area around Pereira Barreto in **Brazil**, about 400 miles northwest of São Paolo, was originally settled in the 1920s by Japanese immigrants who worked on coffee and sugar plantations along the Rio Tietê. But in the 1990s, the river was dammed to create a hydroelectric power plant, flooding and permanently submerging many farms and even a suspension bridge across the Tietê. Today there's a new bridge, and from this angle, the body of water looks like a millipede.

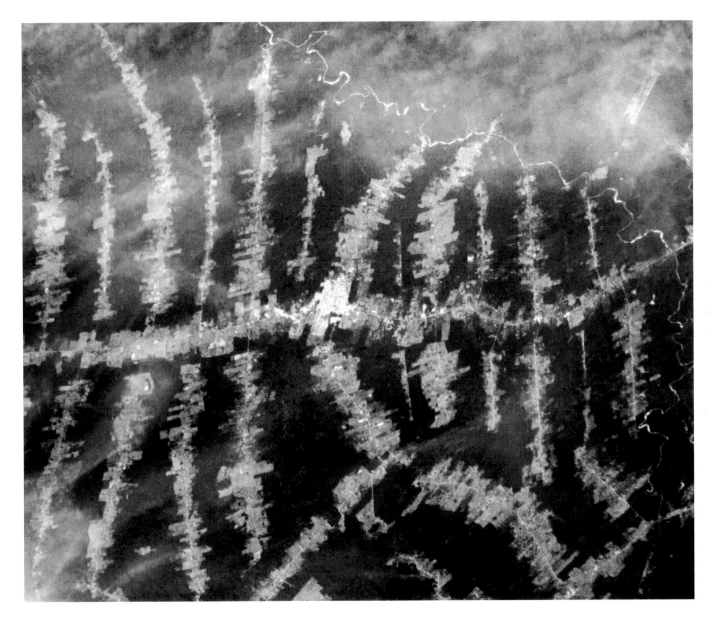

Clearcutting in the Amazon rainforest. That spine across the middle is the central transportation route, and the small town glinting silver and grey is Rorainópolis, **Brazil**. People have pushed out in either direction from that main road, cutting down trees and burning brush—just as people have being doing all over the world for millennia, though no one ever saw the wisps of smoke from a spaceship.

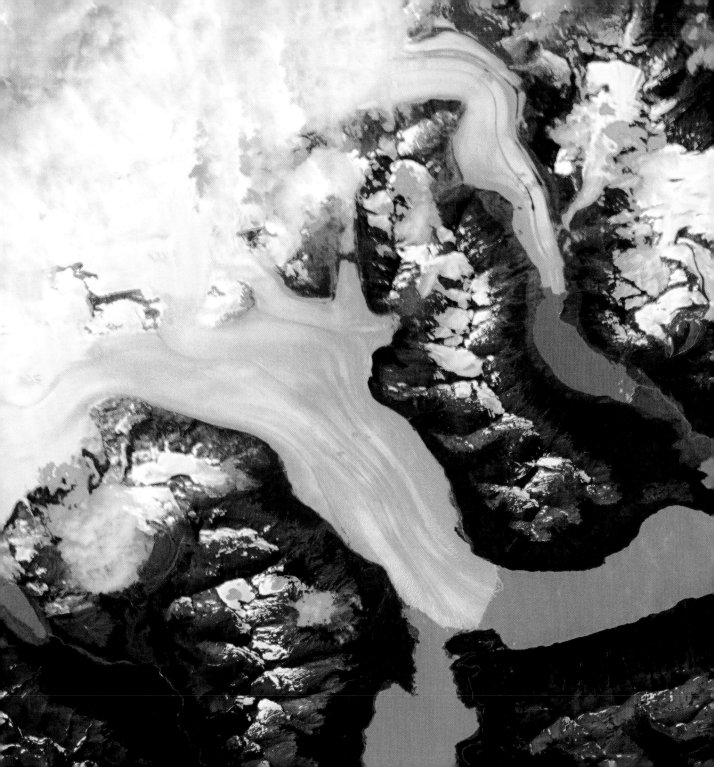

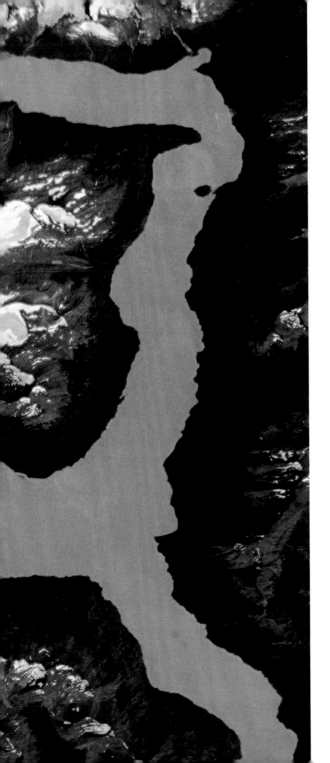

In Patagonia, glaciers slide down the Andes and feed lakes like massive Lago Argentino, which covers more than 550 square miles in southern **Argentina**, very near the border with **Chile**. The tail end of the Perito Moreno Glacier, on the left, is about three miles long and constantly sliding down that slope, loudly plopping huge shards of ice into the water and tinting it whitish-green with powdered rock.

173

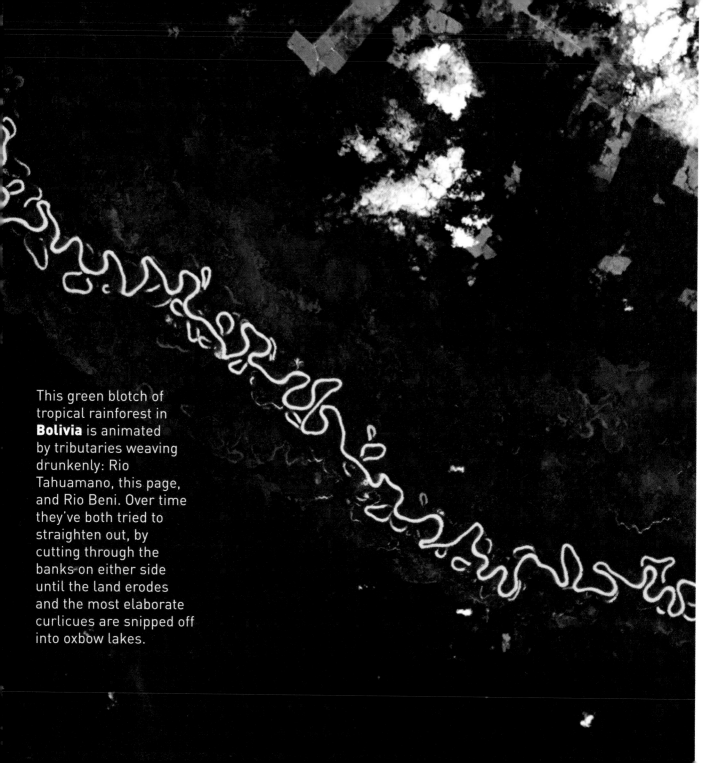

This green blotch of tropical rainforest in **Bolivia** is animated by tributaries weaving drunkenly: Rio Tahuamano, this page, and Rio Beni. Over time they've both tried to straighten out, by cutting through the banks on either side until the land erodes and the most elaborate curlicues are snipped off into oxbow lakes.

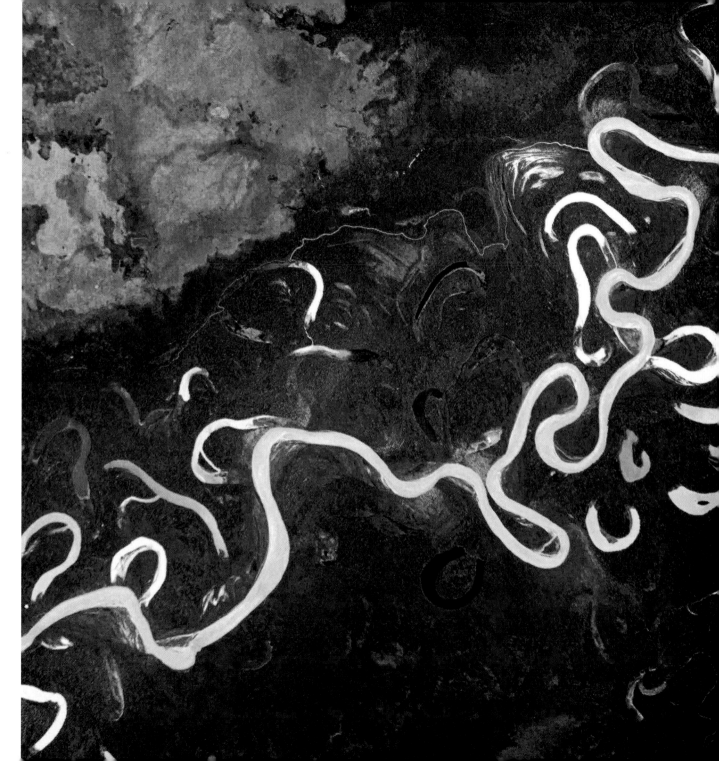

These are:

a. Clouds

b. Water

c. Salt flats

d. All of the above

Answers, clockwise from top left: d, pillows of cloud atop the Salar de Uyuni, the world's largest salt flats; b, the Pacific off the Santa Elena Peninsula; a, off the South Atlantic Ocean coast; a, northwest Brazil

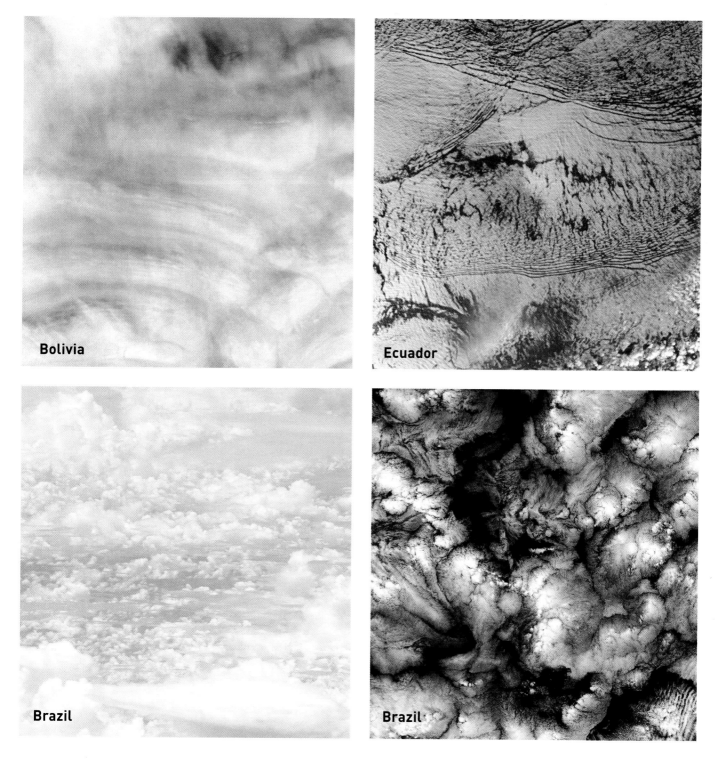

Bolivia

Ecuador

Brazil

Brazil

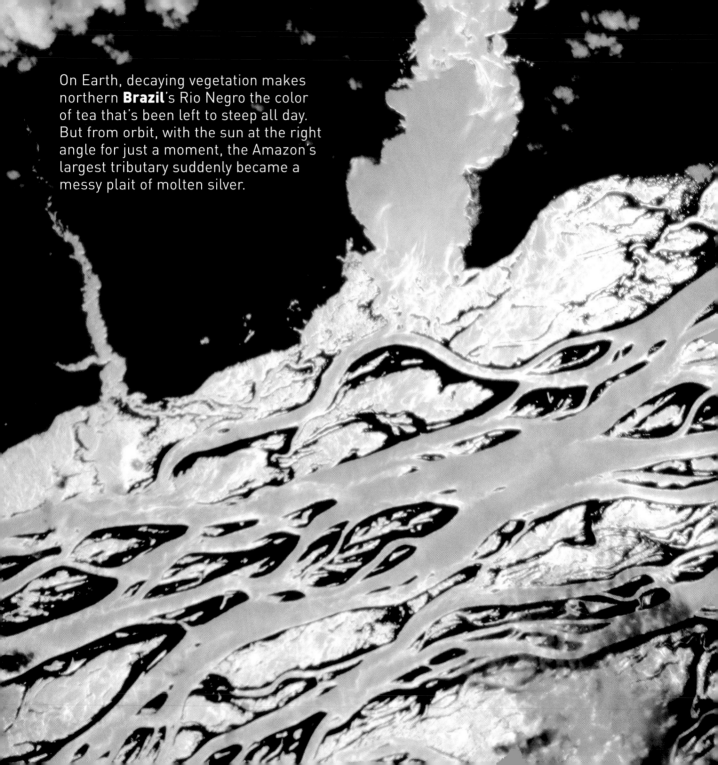

On Earth, decaying vegetation makes northern **Brazil**'s Rio Negro the color of tea that's been left to steep all day. But from orbit, with the sun at the right angle for just a moment, the Amazon's largest tributary suddenly became a messy plait of molten silver.

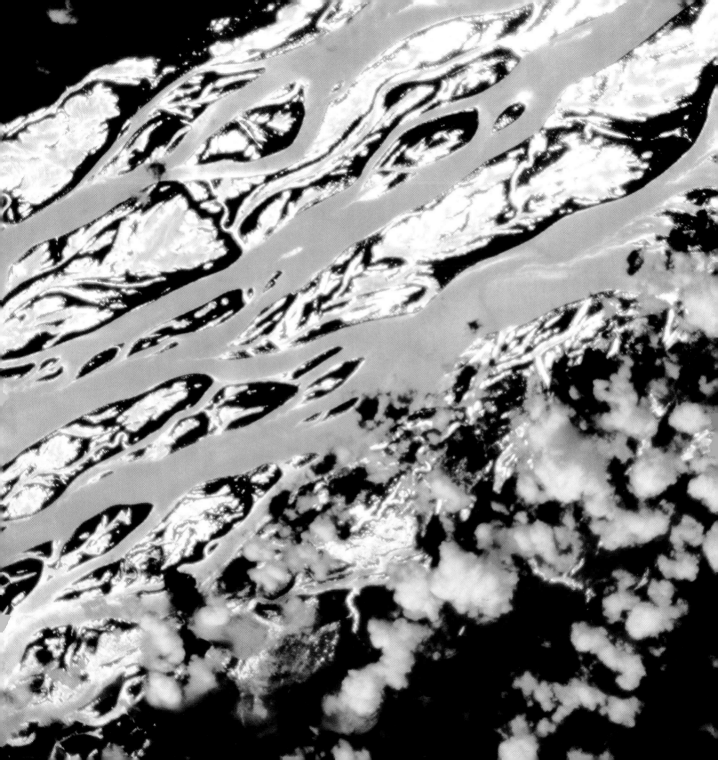

 These hills in Defensores del Chaco National Park, Paraguay, have been whittled by time and weather into this peculiar outcropping, about 25 miles in diameter. The surrounding Chaco is a fairly dry alluvial plain, created by deposits of sediment left behind by rivers, so this upwelling of hills is particularly unusual. It looks as though it was created by some of the same tectonic forces that gave rise to the Andes, a little farther west. There are brain-like formations all over the planet but this is one of my favorites, because the colors of the vegetation make it look like something Dr. Frankenstein dreamt up.

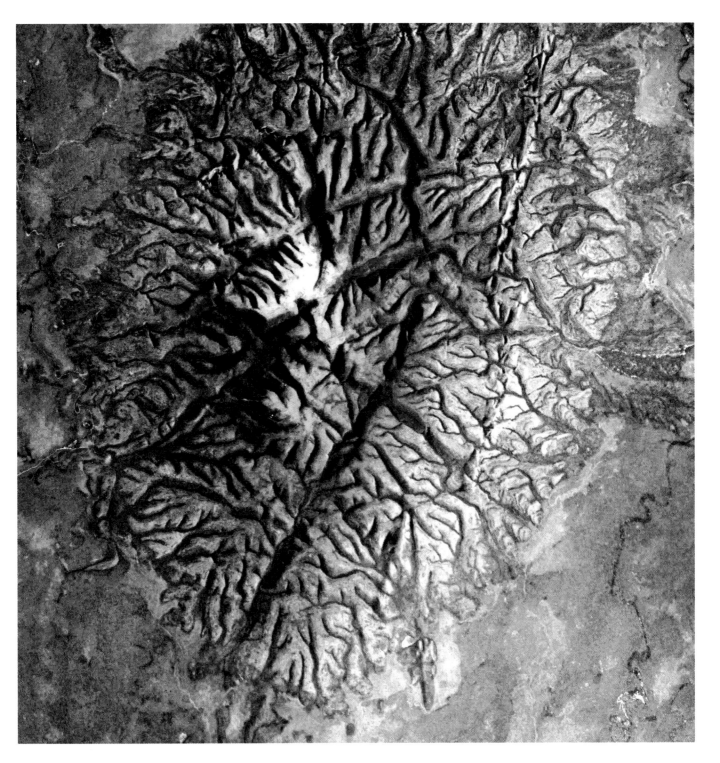

Water is the language of life.

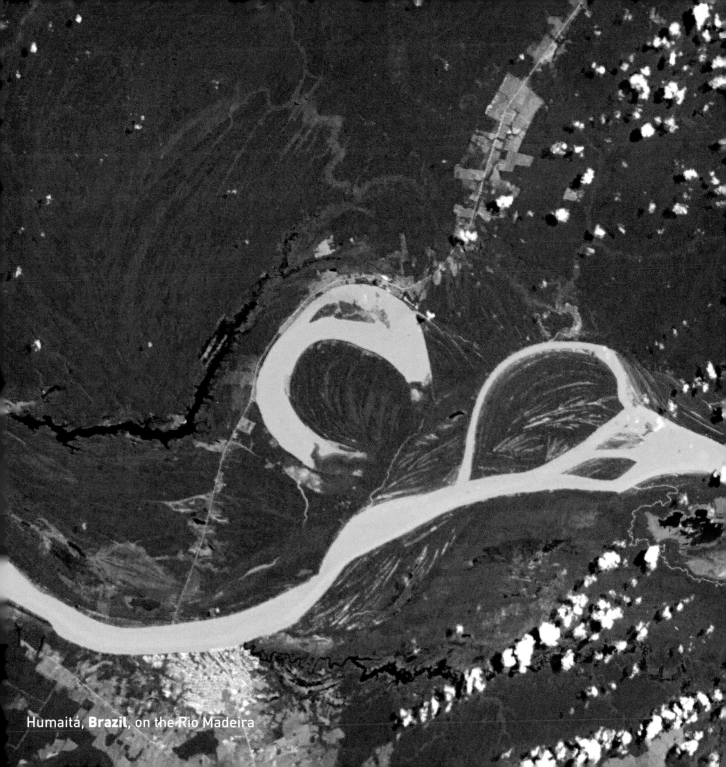

Humaitá, **Brazil**, on the Rio Madeira

Most farmland looks highly geometrical from space: borders are ruler straight. Around Araxá, **Brazil**, farming techniques are modern but ancient settlement patterns are encrypted in the landscape: property lines appear to have been dictated by topography and treelines rather than the imperatives of modern farming equipment.

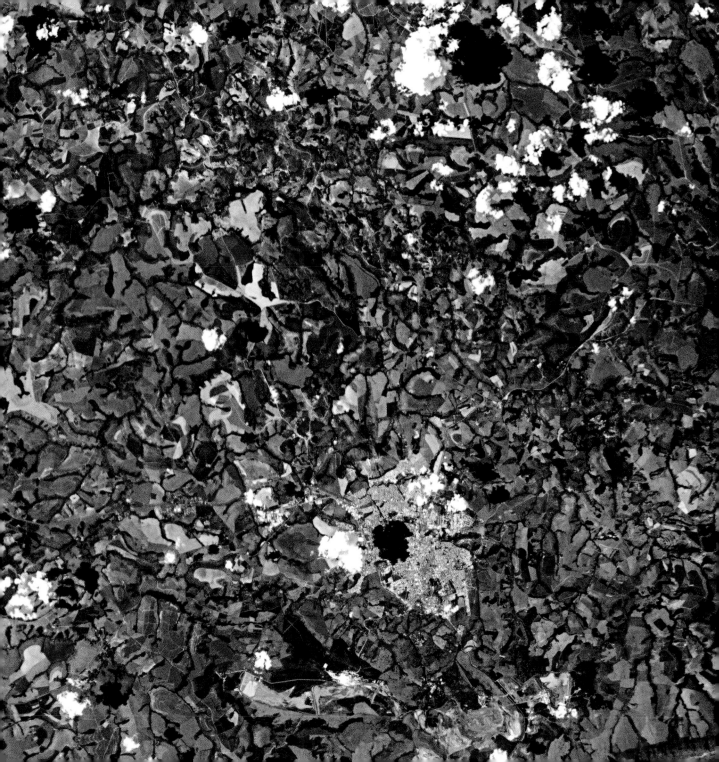

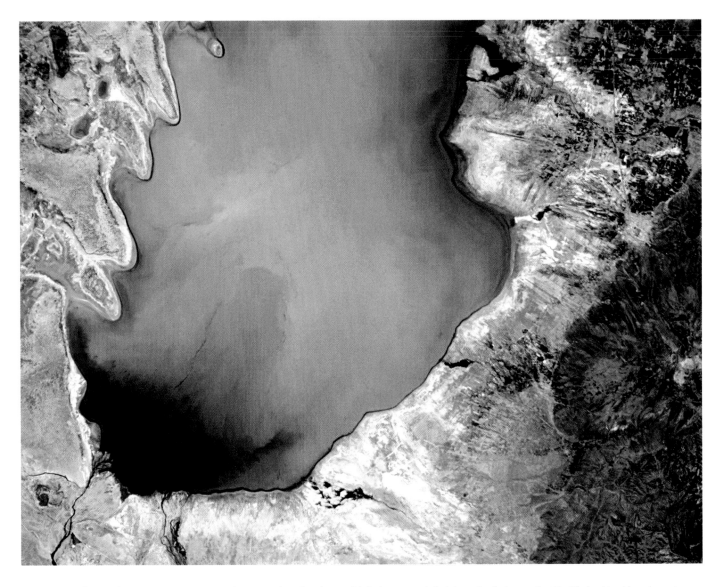

Lake Poopó oozes green murk atop the Andean Altiplano, a highland plateau in **Bolivia** that's about 12,100 feet above sea level. Large but shallow, Poopó has no major outlets, so the brown sediment carried in by the Desaguadero and Márquez rivers stays put and, along with green algae, gives the lake the look of a science experiment gone awry. The indigenous and migratory birds that gather there aren't put off by the colors, but the lake's shrinkage does threaten their survival: the highlands are arid to begin with, but climate change has affected both the flow rate of the rivers that feed Poopó and the lake's own evaporation rate and salinity. Over the past 25 years its surface area has been halved.

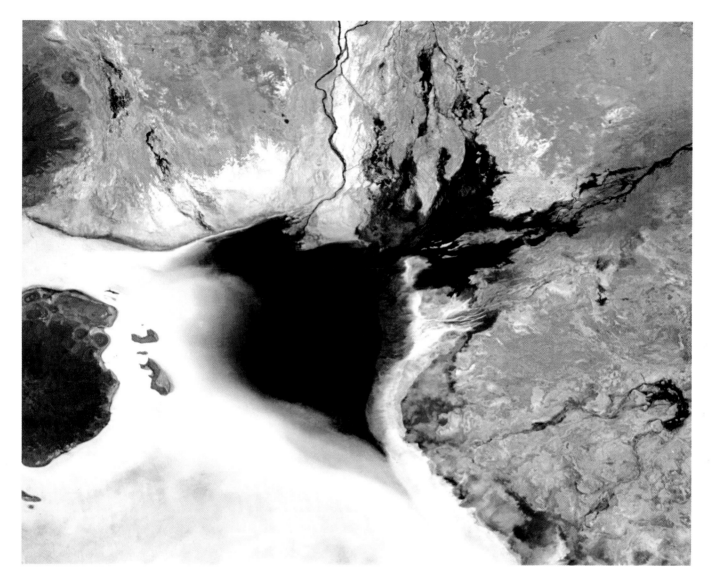

A little to the southwest, still in the highlands, a splash of dark sediment from the Lauca River is a bloodstain against the dazzling white of the 960-square-mile Salar de Coipasa. **Bolivia**'s salt flats, the world's largest, are ghostly remnants of evaporated lakes, trapped in closed basins. Today, the flats' thick, remarkably even crust attracts flamingos, which thrive in high salinity environments— and their highly reflective vast surfaces are perfect for calibrating the altimeters of satellites, providing far more accurate elevation readings than any ocean.

About 180 miles northwest of Buenos Aires, the Rio Paraná is a sharp dividing line. On one side, prime real estate for humans: Rosario, one of **Argentina**'s biggest cities, is a busy port that ships out tons of grain and other locally grown products.

On the other side, prime real estate for capybaras: soggy wetlands alongside the continent's second-longest river appeal to the planet's largest rodents, which are semi-aquatic. The Paraná is also home to many different types of birds and fish, including piranhas (which have been known to enjoy the occasional capybara).

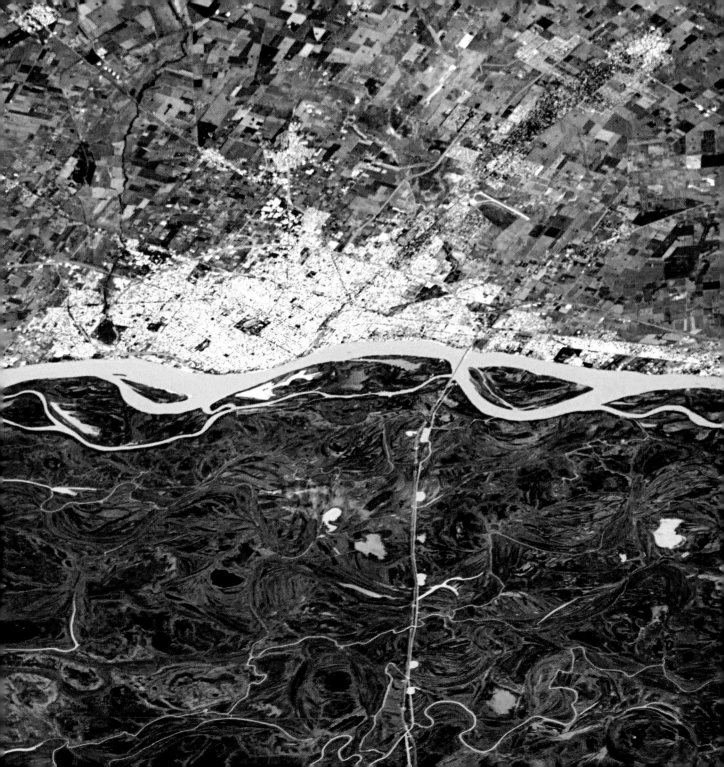

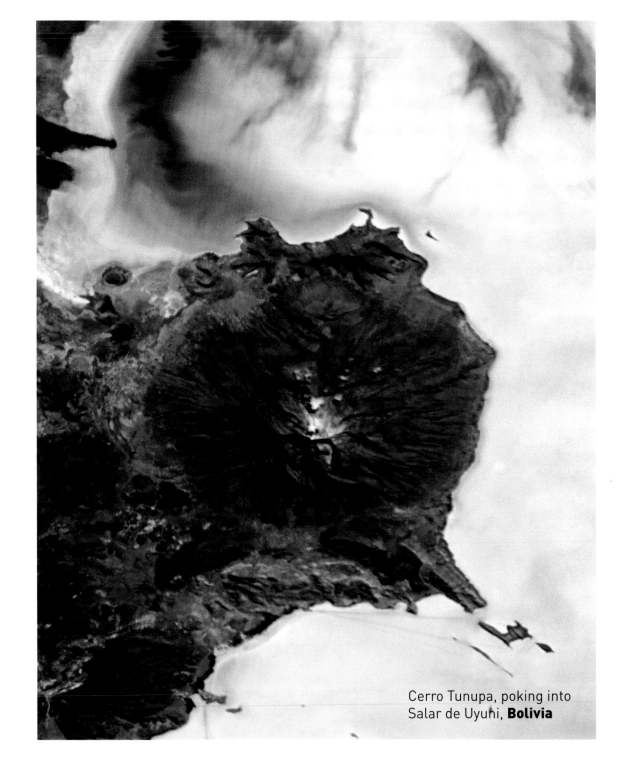

Cerro Tunupa, poking into
Salar de Uyuhi, **Bolivia**

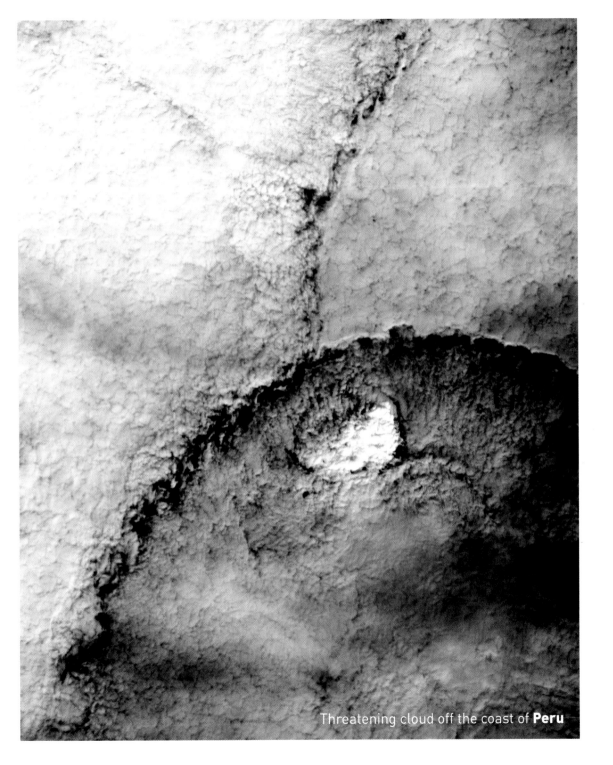
Threatening cloud off the coast of **Peru**

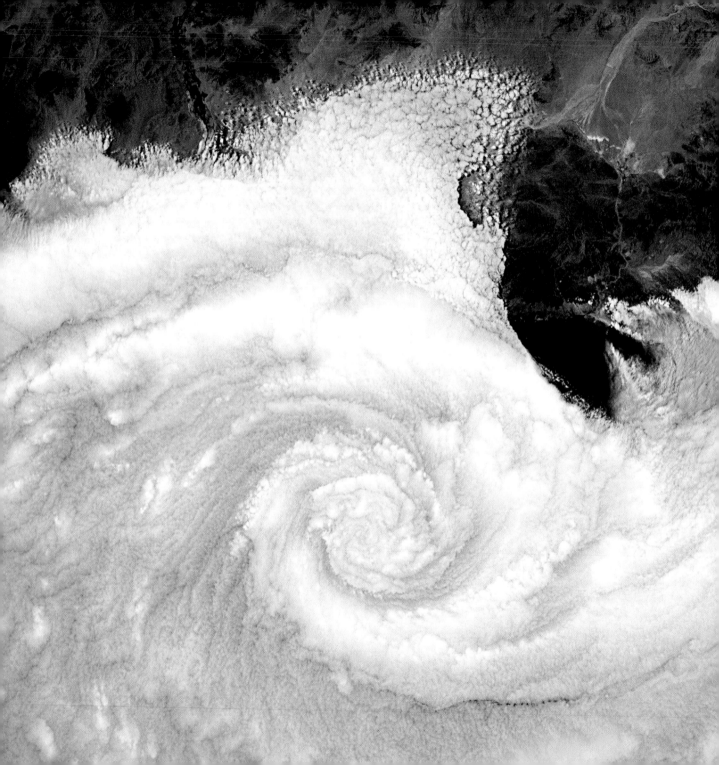

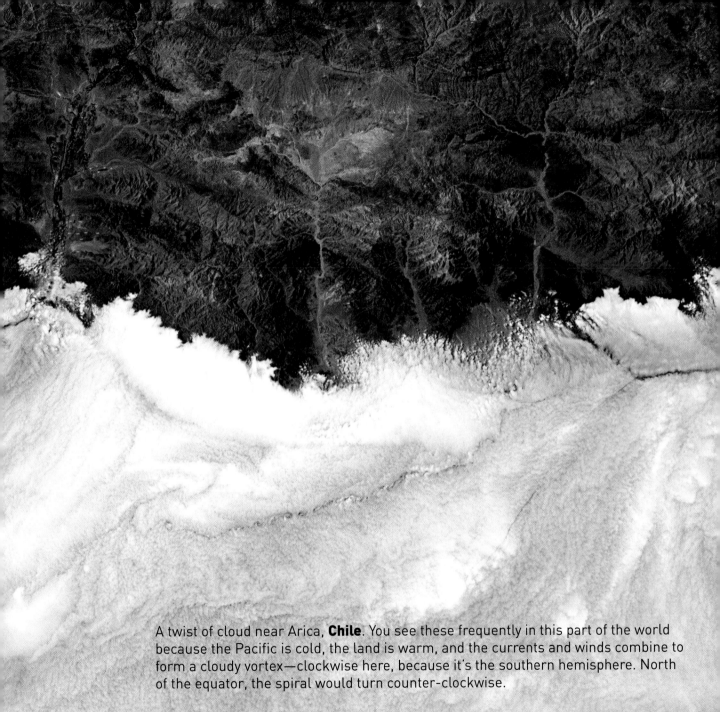

A twist of cloud near Arica, **Chile**. You see these frequently in this part of the world because the Pacific is cold, the land is warm, and the currents and winds combine to form a cloudy vortex—clockwise here, because it's the southern hemisphere. North of the equator, the spiral would turn counter-clockwise.

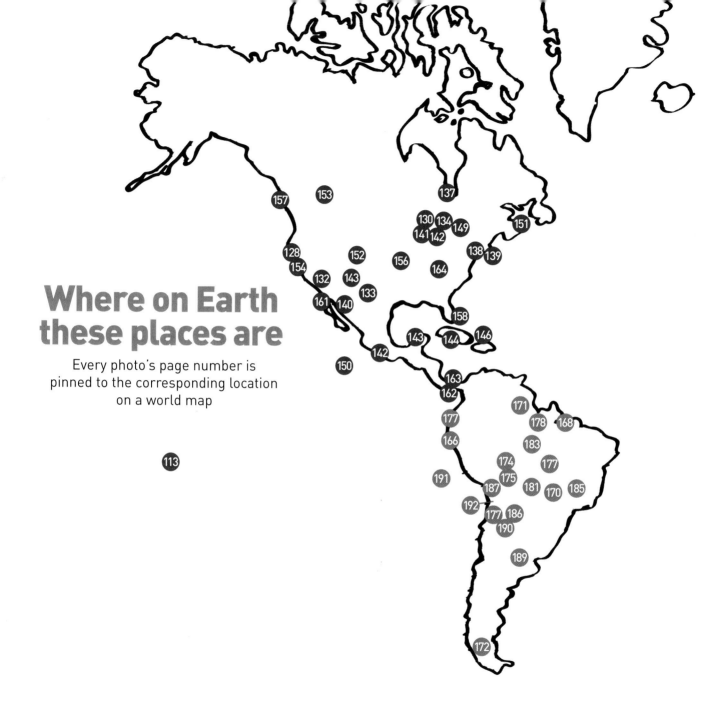

Where on Earth these places are

Every photo's page number is pinned to the corresponding location on a world map

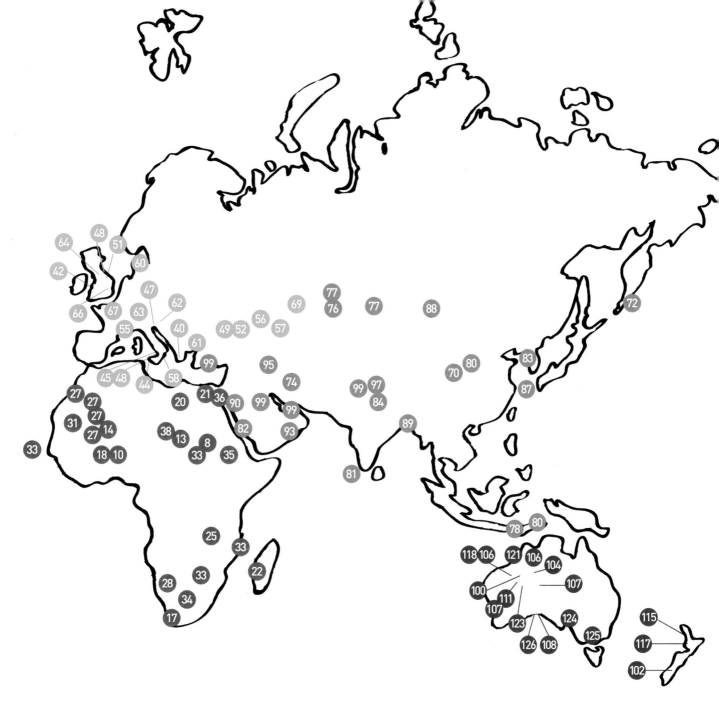

Acknowledgments

This book is the combined work of many talented and motivated people. My hope is that you find it beautiful and rewarding, and that it shows you something fresh and exciting about the planet we share.

Specifically, I want to thank everyone at the Canadian Space Agency and at NASA, who enabled, supported and taught me so much. Every time I pushed the shutter in orbit I thought of my luck to be there, and the debt that I owe to each of you. I hope you are proud as I am of the work displayed on these pages. I especially owe it to my photography instructors, who painstakingly repeated themselves for twenty years in hopes that I would some-day know what to look for, and what to do with the camera when I saw it. Next time I'm in Houston, beers are on me.

The team that helped conceive the book, choose and sort the photos, and place them so elegantly and whimsically onto paper is world class. Kate Fillion, my collaborator on every-thing from the structure of the book to finding the perfect word, was passionately, endlessly inventive about ways to display the images, working with designer Bryan Erickson to meticulously create the true art that is on each page.

My publisher at Random House Canada, Anne Collins, gracefully helped shape the book you hold in your hands, working hard to deliver a new way to showcase images of our Earth; I also appreciate the support I've received from John Parsley at Little Brown in the United States and Jon Butler of Macmillan, my publisher in the UK. Special thanks to my superb literary agent, Rick Broadhead—kind, trusted and tireless.

I am especially grateful to geographer Dave MacLean, whose encyclopaedic knowledge, diligence and patient good humour were key to ensuring that the location of each photo was accurately understood—a far harder job than anyone would assume. Thanks also to Tim Braithwaite, Aaron Murphy and Craig Walter for your all-hours, painstaking help.

Finally, I love and wish to thank my family, especially Evan, who was the first to appreciate the thousands of photos I took during my last mission and who counsels me so well. Most of all I owe this to my wife, Helene, who came up with the title, kept us true to the spirit of that phrase, and whose confidence and clarity enable all.

Image Credits

All images credited NASA/Chris Hadfield, unless specified otherwise below.

Chris Hadfield in ISS cupola. © NASA/Tom Marshburn; Photo frame. © iStock.com/ Tolga_TEZCAN

Page 12. Egg. © iStock.com/blackred

Pages 16, 46, 96, 112, 148, 173. Photo frame. © iStock.com/Tolga_TEZCAN

Page 16. Cape Town. © iStock.com/ michaeljung

Page 30. Target. © iStock.com/jangeltun

Page 39. Cheerio. © iStock.com/chrisbence

Page 46. Venice. © iStock.com/fazon1

Page 50. Quilt. © Shutterstock.com/ MARGRIT HIRSCH

Page 68. Ink splatter. © iStock.com/andylin

Page 75. Jupiter. © iStock.com/martin_ adams2000

Page 86. Dot-to-dot. © Bryan Erickson

Page 92 a. Chex cereal. © Bryan Erickson

Page 92 b. Sponge. © Shutterstock.com/ MAHATHIR MOHD YASIN

Page 92 c. Brick wall. © iStock.com/cromer

Page 92 d. Sand. © iStock.com/ TarpMagnus

Page 96. Himalayas. © iStock.com/ IgnacioSalaverria

Page 109. Anteater. © iStock.com/ Ace_Create

Page 110. Gwion Gwion figures. © Bradshaw Foundation

Page 112. Tongareva, Cook Islands. Photograph by Ewan Smith

Page 116. Eye. © iStock.com/bikerboy82

Page 120. X-ray. © iStock.com/bjones27

Page 122. Microscope. © iStock.com/ furtaev

Page 124. Turtle. © iStock.com/amwu

Page 125. Dinosaur. © iStock.com/Becart

Page 136. Zipper. © iStock.com/ t_kimura

Page 148. Toronto. © iStock.com/ Orchidpoet

Page 152. Wolf. © iStock.com/Vectorig

Page 153. Coyote. © iStock.com/Darren-Mower

Page 160. Mexican flag. © iStock.com/ inhauscreative

Page 160. American flag. © iStock.com/ claudiodivizia

Page 173. Patagonia. © iStock.com/ IvonneW

Page 180. Brain. © iStock.com/DNY59

Page 184. Camouflage hat. © iStock.com/ ascender416

Page 190. Bird. © iStock.com/4x6

Page 191. Bomb. © iStock.com/ DoodleDance

Page 194 – 195. World map. © Shutterstock.com/Ohmega1982

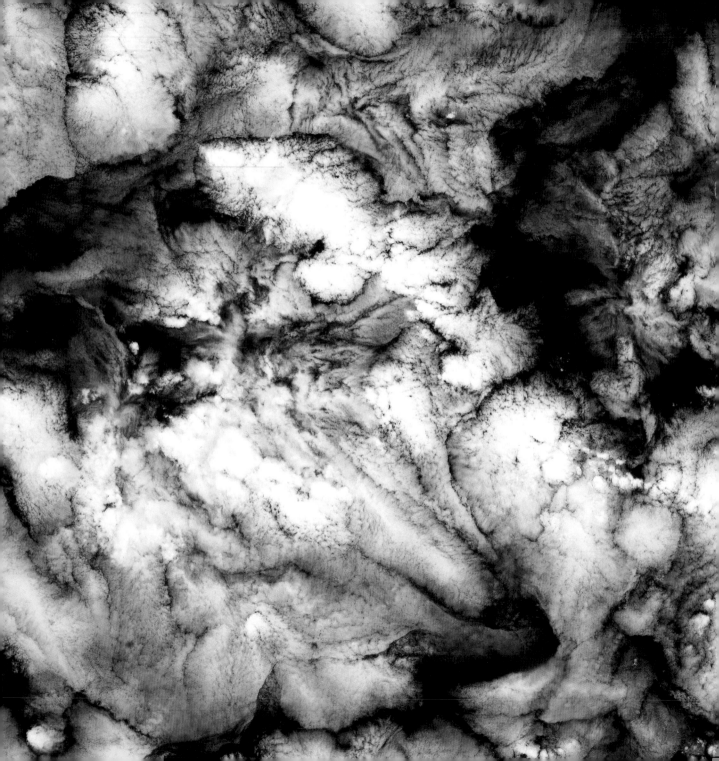